LEYLAND
THEN & NOW
IN COLOUR

DAVID HUNT & WILLIAM WARING

COLOUR PHOTOGRAPHY BY DAVID ASHMORE

The
History
Press

In memory of Gwen Buckley (1909-2011)

First published in 2012

The History Press
The Mill, Brimscombe Port
Stroud, Gloucestershire, GL5 2QG
www.thehistorypress.co.uk

British Library Cataloguing in Publication Data.
A catalogue record for this book is available from the British Library.

ISBN 978 0 7524 7743 5

Typesetting and origination by The History Press
Manufacturing managed by Jellyfish Print Solutions Ltd
Printed in India.

CONTENTS

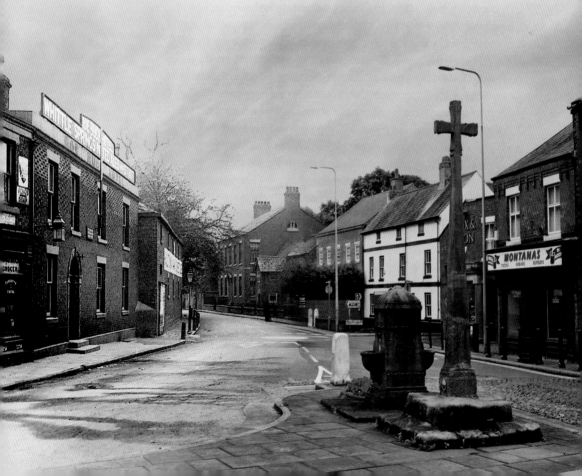

ACKNOWLEDGEMENTS

The historic photographs in this book are largely but not exclusively drawn from South Ribble Borough Council's local history collection, housed at the Museum & Exhibition Centre in Church Road, Leyland. The various donors and people making material available for inclusion were thanked in *The Archive Photographs Series: Leyland* (1995, 2006), from which most of the 'then' photographs in this new publication are derived. Royalties were divided equally between the Leyland Historical Society and the Museum's small acquisitions fund, from which James Alan Hill's fine painting 'Leyland from Whittle Hills' (1956) was duly purchased for permanent display. Author's royalties arising from this book are to be donated in their entirety to St Catherine's Hospice. Once again, many people have offered their help and we are grateful to Caroline Taylor, David Pollard, Jennifer Clough and South Ribble Borough Council, Steve Whelan and Leyland Trucks, staff at the British Commercial Vehicle Museum, Simon Court and Tesco Leyland, Wilf Wasteney (who volunteered for the proof reading) and Chris Woodhead (who bravely obtained the spectacular photograph from the roof of the old post office). To these and anyone we have inadvertently omitted, we are most grateful.

ABOUT THE AUTHORS

Dr David Hunt has been the curator of Leyland Museum since 1982, and was the first visiting fellow in Local & Regional History at the University of Central Lancashire.

William Waring, president of Leyland Historical Society, has spent many years researching all aspects of the history of his birthplace. He has been published extensively in the magazine of the Leyland Historical Society.

David Ashmore has been a keen photographer since the age of eleven, and was a teenage member of the prestigious Leyland Photographic Society. He worked for the local authority, where he was chauffer until retiring in 2009. He now has the time to enjoy his early interests in local history and photography.

INTRODUCTION

'No man is an island, entire of itself:
every man is a piece of the Continent, a part of the main.'

John Donne (c.1571-1631)

This book contains two distinct collections of photographs, taken perhaps eighty years apart. They illustrate life in two Leylands, and each might be read separately from the other. One is a foreign place, or a childhood memory at best, and we live in the other. From 1880 the town was at the forefront of the second industrial revolution, feeding the demand for wonder products of all kinds. Flat building land was plentiful and cheap, communications were good and the world's demand was insatiable. North of the ancient village, clustering around the cross, it comprised little more than a faint ribbon of houses, and was quickly overwhelmed by the Leyland Motors factories. It scarcely had the time to evolve a regular plan or even a town centre, was a place of noise, smoke and acrid smells and had a dirty Gas Works at its heart. After 1920 it would take almost a century to sort these problems out. By then intensifying waves of economic and social change sweeping in from the global economy would have created our Leyland. Of course, hubris and human error, as well as much creativity, also play their part in our unfolding story.

This Leyland is very much a product of the release of forces for change long restrained by the depression of the 1930s and the Second World War. War was the critical driver of growth in the first half of the century but left Leyland little more than an enlarged village amidst internationally important manufacturing plants, to which the enormous Royal Ordnance Factory had been added. But these were good years, years of near full employment amidst the collapsing Lancashire cotton industry. The 1930s had seen the development of housing of a very high standard; here the semi-detached house with gardens front and back was the Leyland norm. The old Urban District Council adopted the motto 'We Continually Progress' and with the purchase of Worden Park – the highlight of the 1951 Festival of Britain celebrations – local optimism knew no bounds. A booming town must be in want of a modern town centre. Might it support a New Town in Central Lancashire?

Leyland Motors probably reached the zenith of its greatness in 1968, but like much of British industry it fell into a steep decline in the years 1979-87. This was serious, for, as Bill Waring has said, 'In many ways Leyland Motors was Leyland'. The collapse of Leyland DAF in 1992-3 released large quantities of former industrial land for much needed residential and retail development. Likewise, in the decades after 1960 the town centre scheme had steadily degenerated into a series of well meaning but ultimately failed projects. However, during these years of utter frustration, the steady demolition of Western Towngate continued. Both of these logjams began to clear in the late-1990s during the economic upswing of 1992-2008, with some interesting results – as you will see. Leyland Trucks emerged out of the wreckage of British Leyland, and in the next few years should produce their millionth 'Leyland' vehicle; the factory chimneys are gone, gardens and trees abound – yet through it all the motor works still closes at 4.10 p.m. In modern, leafy, suburban Leyland, factories have made way for supermarkets of all kinds, for today it is the consumer who is king and Leyland must serve him. For good or ill, Leyland is a town transformed.

A VISIONARY

OCTAVIUS DE LEYLAND Baldwin, vicar of Leyland 1891-1911, leading prayers around Leyland Cross, perhaps at the conclusion of a Whitsuntide walk, in around 1905. 'Occy Baldwin' is the figure standing to the right of the cross. The Baldwin family had supplied the parish's clergy for 165 years by the time of Leyland Baldwin's death in 1913. During the early twentieth century his sale of ancient church lands for the North and South Works of the nascent Leyland Motors ensured that the company and its vast employment opportunities would remain in the area to the present day.
His curate wrote of this colourful social reformer, Irish Home-Ruler and High Church Anglican:

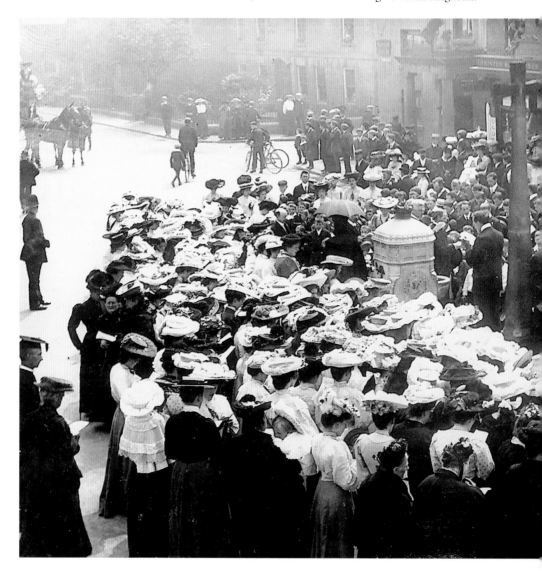

I believe he was ever thinking, not of himself, or indeed merely of the present, but of the future, and of posterity. He wanted Leyland to be up-to-date... in all things which promote the health and happiness of the people at large.

THE SUPERIMPOSITION OF an 'out of town' supermarket onto the medieval centre of Leyland has severed the road junctions around Leyland Cross – Fox Lane and Church Road – from their outlet to the north. Much of Towngate appears to have been lifted out – or 'deleted' – and its continuation at the corner with Lancastergate can be seen here beyond the car park. Leyland Cross has done well to survive these changes, being the natural enemy of cars, wagons and tanks and losing at least four arguments with them. In June 1986 yobs pulled it down to the stump. This was a perilous time for the landmark, and the possibility of moving it to a new location was discussed. Investigations revealed that it stood on four concentric steps, of which only two are visible today. The large well was intact beneath the pump, making removal controversial and expensive.

WEAVERS' HOUSES, UNION STREET

LOOKING WEST DOWN Fox Lane from the junction of Towngate and Worden Lane on a cold day, c.1900. The building on the left is Occleshaw House, and that on the right the Bay Horse Inn. From

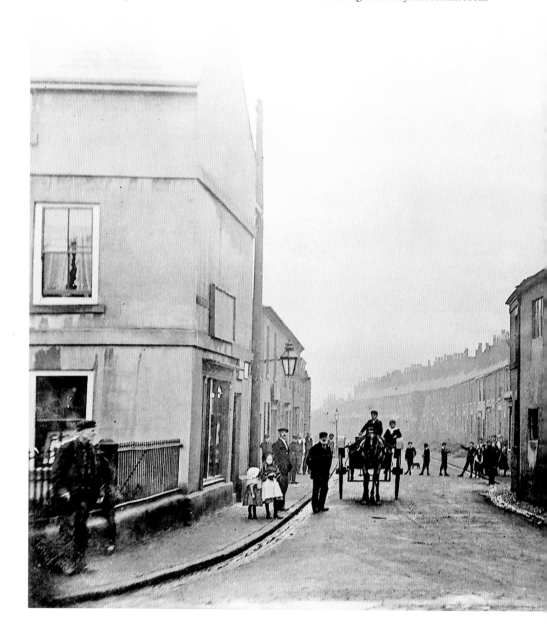

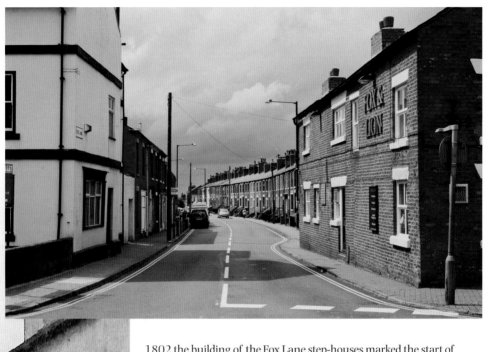

1802 the building of the Fox Lane step-houses marked the start of industrial development in Leyland. Beer paid for the scheme: George Bretherton of the Bay Horse purchased the old medieval fieldstrip behind his premises in 1794, and other prime movers were Agnes Critchley of the Roebuck Inn and the Rufford maltster John Norris at the Eagle & Child. The property, known as Union Street, was developed by a terminating building society, with strict rules and a regular plan. Twenty-two two-storey cottages over weaver's cellars were built in the subsequent years. Members paid a regular subscription and houses were built in blocks (4-12-6) as funds allowed. Completed houses were balloted out. This continued until each member had 'won' a house, whereupon the society terminated.

SAFELY WITHIN THE conservation area, this southern section of the village centre has fared relatively well. The Bay Horse is reborn as the Fox & Lion, whilst Occleshaw House, on a site dating from the 1280s, has undergone many changes of occupancy.

Leyland's road layout developed to move crops and animals and proved inadequate for modern needs. This junction between principal north-south and east-west routes remains very difficult and was little improved by the closing of Towngate to traffic at the Cross. Today this is one of the pressure points in the local transport system. Plans to develop new routes across the town were promoted either side of the 1940s but came to nothing.

WEAVERS' HOUSES, UNION STREET

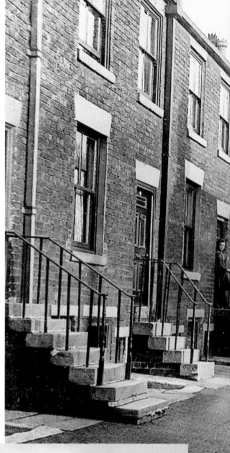

UNION STREET, C.1909. This is the classic view of the Leyland weavers' houses, and the Agricultural Hall can be seen on the right. The parish church dominates, and in the absence of clutter and cars it is refreshing to observe how attractive much nineteenth-century property was. Perhaps up to 100 looms could have been at work here. Horrockses, Miller & Company had their warehouse by Leyland Cross and a trade running into several thousand pounds a year.

In the 1780s local weavers had specialised in the manufacture of Osnaburg – cloth for use as slaves' clothing in the West Indies – and despite occasional upsets, the trade expanded steadily. The weaving boom lasted well into the 1820s but entered a long decline thereafter. In 1838 the *Preston Chronicle* reported that the local weavers 'of that beautiful village... complain very much of the hard times, wages have been very low for some time past'.

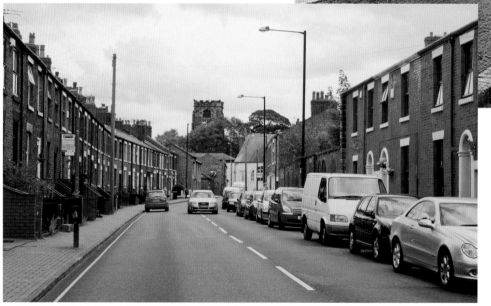

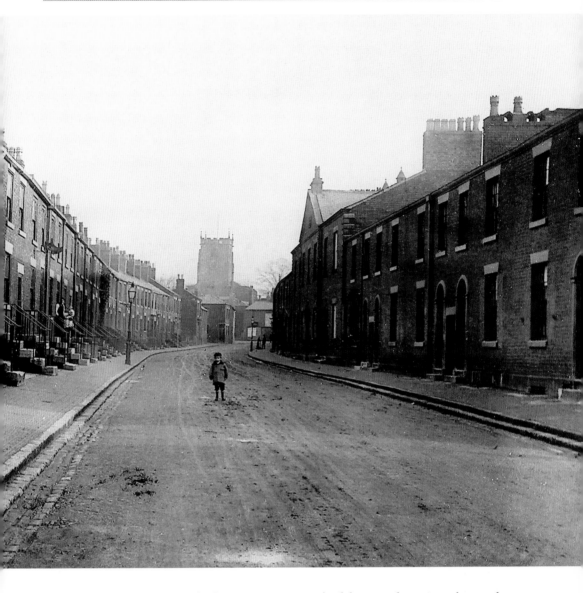

ARGUABLY, UNION STREET is the finest surviving example of this type of weaving colony, and
this interesting corner of old Leyland survives largely intact. The streetscape was extensively
refurbished in the late-1980s and a number of the old weaving cellars have been converted
into their modern equivalent: digital offices. All this makes them thoroughly modern homes at
the start of their third century, a fitting place for Sally Magnusson to record the BBC's 2011
'Census Special', and worth a closer look. A few of the original beautifully wrought iron railings
survive at the step-houses. On the right, the fine detail of many doorways and their arched lights
still exude a Regency air. The great change here has been the collapse of the former Leyland
Agricultural Hall, or Union Hall, which had housed the Top School from 1874-1938. Clearly, in
the 1850s this was a rather fashionable row, which recent work has done much to revive.

WEAVERS' HOUSES,
BRADSHAW STREET

THE BRADSHAW STREET step-houses, *c.*1900.
The success of 'Union Street' led to plans for the
Bradshaw Street colony, established in 1806. John
Bradshaw, a local builder, was a guiding light of the
project that included the George IV public house
(now Barristers). By 1841, however, the number of
weavers in 'Union Street' had fallen markedly; over
a hundred weavers were still at work in Bradshaw
Street. In the final third of the century, the last of
Leyland's handloom weavers were to be found here.
The property does not seem to have been of the
quality of the earlier houses, and the Leyland Local
Board (the precursor of the Urban District Council)
fought many battles with recalcitrant landlords. In
1880, fifteen houses were reported to be without
back door, privy or drain, and in the winter the
cellars flooded. The houses on the left near the top
of the street were Orange Square, a distinct but
related weaver development.

THE MODERN PHOTOGRAPH shows Spring Gardens. Steady demolition of the property opened the door to redevelopment. In the 1930s council housing was built along the north side, which, after refurbishment, became the first public housing in the country to have solar heating panels fitted as standard – a historic first for the 'town'. The right-hand side was redeveloped as 'Lancastergate', providing a purpose-built public library, law courts and police station. With the Leisure Centre on the south side and the construction of the extensive Council Offices and various health-based facilities in West Paddock, this block emerged as the public zone for the New Town. In the 1960s it was envisaged that it would be adjacent to the market and the Metrolands shopping centre development, within an existing pattern of small shops and offices. The bricked-up cellar windows of a solitary surviving weaver's house in vanished Orange Square are the only clue to the area's colourful past.

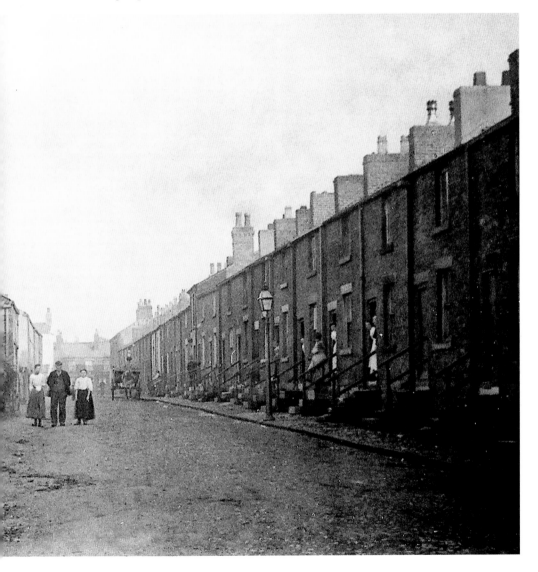

WEAVERS' HOUSES, FINCH'S HOUSES

FINCH'S HOUSES, WATER Street, 1934. This neat row of weavers' houses, originally known as Finch's Houses, was very typical of smaller weaving ventures. In 1841 twenty-five weavers were at work in the dozen houses. The solitary chimney pots give a clue as to how the internal accommodation was arranged. Only one room could be heated, presumably the one in which cooking was undertaken. The kitchen was thus the main room and the working cellars had no heating. The practice of subletting cellars to poorer families may thus not have been so attractive here as in Union Street, where many homes were sublet and are well provided with fireplaces. Beyond these multiple house developments, smaller, less specialised property could be found at the west ends of Golden Hill Lane (Heaton Street) and Fox Lane (Walton's Row).

THE LATE PETER Barrow argued that the original settlement of the Leyland area was closely related to the distribution of late glacial sands. Subterranean waters draining westerly from the Pennines were tapped in the sands here by wells. Water supply was an important resource for the village blacksmith, whose forge was located here in the white-painted

building at the extreme end of Water Street. His son James was born in one of Finch's Houses in 1859, and the embryonic Leyland Motors would emerge from the smithy thirty years later. After the demolition of the weaving property, the site was developed as the town's first formal open market. It served the town up to the move to the Leyland Cross site at the opposite end of Towngate, and ultimately to the present building in the former North Works. The site was then cleared and successfully developed as a sheltered-housing complex.

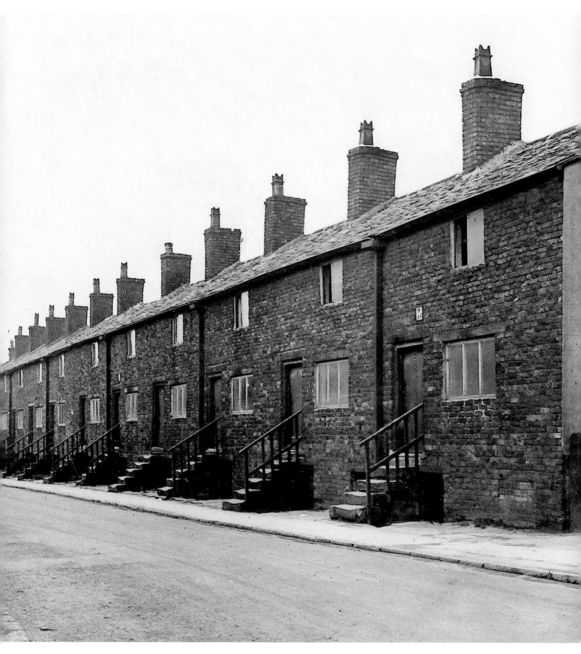

EARNSHAW BRIDGE MILL

PILKINGTONS' EARNSHAW BRIDGE Mill, *c*.1910. Both Earnshaw Bridge and Seven Stars grew up around moderately sized cotton mills in the middle of the nineteenth century. Located by streams, here the River Lostock, steam plants were critical to the success of the enterprises and in this flat country their mill chimneys were familiar landmarks. Established by a former Fox Lane step-house man – Francis Sergeant Pilkington – and his son John in 1845, Earnshaw Bridge was Leyland's first cotton mill. It was seriously affected during the Cotton Famine and was still closed in 1865. Both spinning and weaving were carried on, and in the 1860s 'Mr Pilkington' had five mules turning 6,600 spindles; by 1939 'John Pilkington Ltd (1900)' was running 809 looms. Working

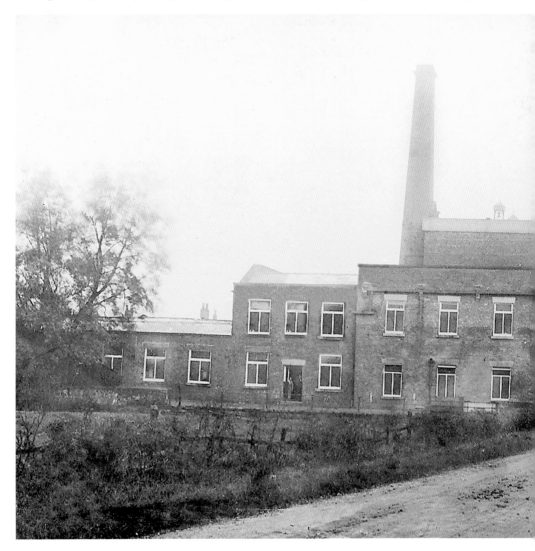

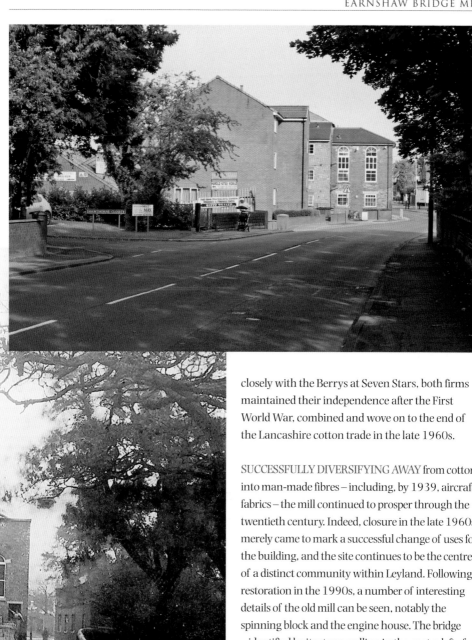

closely with the Berrys at Seven Stars, both firms maintained their independence after the First World War, combined and wove on to the end of the Lancashire cotton trade in the late 1960s.

SUCCESSFULLY DIVERSIFYING AWAY from cotton into man-made fibres – including, by 1939, aircraft fabrics – the mill continued to prosper through the twentieth century. Indeed, closure in the late 1960s merely came to mark a successful change of uses for the building, and the site continues to be the centre of a distinct community within Leyland. Following restoration in the 1990s, a number of interesting details of the old mill can be seen, notably the spinning block and the engine house. The bridge – identified by its stone walling in the centre left of this picture – is not the original 'Earnshaw Bridge' that carried Leyland Lane over the River Lostock. The place name appears in the 1300s as Erenes Haigh, the *haugh* (cultivated ground by a stream) belonging to a man named Earne. Eilert Ekwall interestingly adds that Earne could be derived from the Old English word for an eagle.

THE LEYLAND &
BIRMINGHAM
RUBBER COMPANY

AERIAL PHOTOGRAPH OF the Leyland & Birmingham Rubber Company, *c*.1935. From the 1870s Leyland was at the forefront of the second industrial revolution. The rise of the rubber industry may have had its origins in the efforts of local weavers to diversify into waterproof cloths. A trade directory

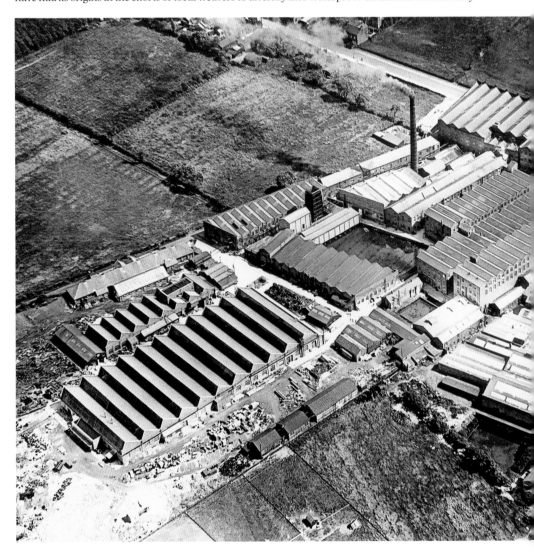

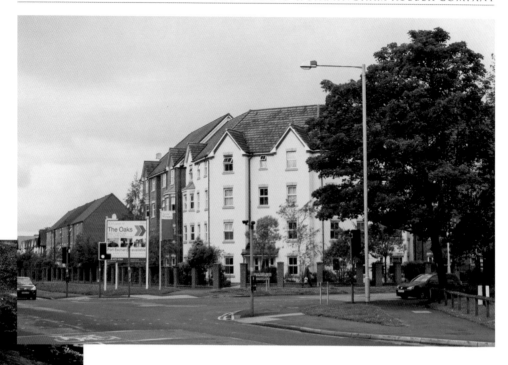

of 1851 lists William Smith, a 'Manufacturer of waterproof cloths, piping and washers, Golden Hill Lane'. After his death in 1861, James Quin, 'a manufacturer of India rubber, hose pipes, gutta percha etc', took over the business and established it on the old Leyland Workhouse site. Progress was rapid, with the formation of James Quin & Company in 1873, the Leyland Rubber Company in 1886 and ultimately the Leyland & Birmingham Rubber Company in 1898. Leyland continued to lead in the field, and by the 1920s was host to a number of rubber manufacturers that became important constituents of BTR Industries. By the 1980s BTR was one of Britain's most successful conglomerates, employing 200,000 people in over 100 countries.

THE MODERN PHOTOGRAPH shows Heys Hunt Avenue. By the 1980s the long run of British pre-eminence in the heavy industries was long over. With the ending or moving of production, wide flat tracts of the town became available for redevelopment and therefore attractive to developers. In Leyland peripheral locations tended to be used for housing, and the central sites for offices or shops. The Leyland & Birmingham site posed many problems. Deposits of hazardous waste that had accumulated in less environmentally aware times had to be expensively removed. Efforts to save the landmark frontage on Golden Hill Lane foundered when it became apparent that it was little more than a façade, concealing the enormous steel-framed buildings behind it. The last London & Birmingham inhabitants to leave were a shoal of goldfish, rescued from the factory lodge in 2005. The subsequent housing development, centred on Heys Hunt Avenue, takes its name from one of the Victorian workhouse's masters.

LEYLAND MOTORS: THE SUMNER SMITHY

BIRTHPLACE OF LEYLAND Motors: the Sumner smithy in Water Street, *c*.1905. The Sumners had been blacksmiths here since the eighteenth century, when James Sumner (1859-1924) was born at No. 1 Water Street. His father Richard was thirty years of age and is described as 'blacksmith, fitter and turner' at the time of the 1861 census. Conspicuously for the residents of the former

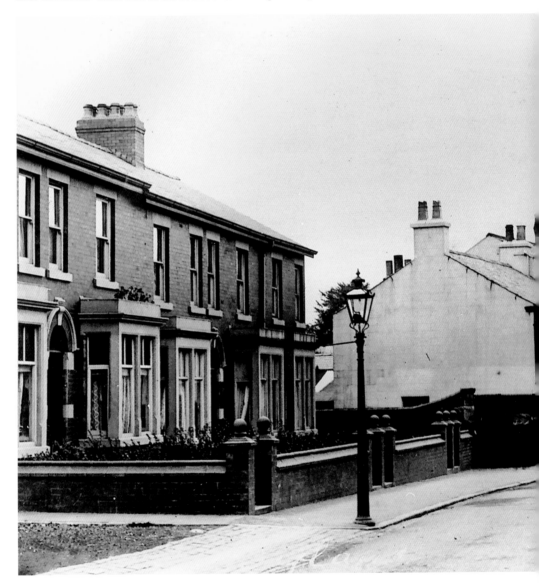

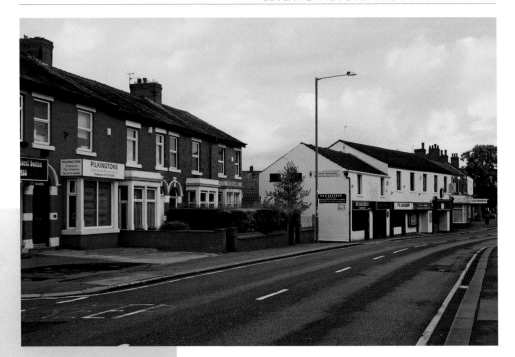

weavers' houses, Richard and his wife Alice were able to afford the services of a 'general servant' – twelve-year-old Elizabeth Prescott. The extension to the early nineteenth-century stone building housed a very adaptable and compact engineering workshop. This was much more than a rural smithy, and perhaps Richard Sumner was no rustic smith. The brick, garden-fronted houses in the foreground are very typical of the high-quality homes built along Hough Lane in the prosperous years before the First World War.

THE WEST SIDE of Water Street. With the formation of the Leyland Steam Motor Company, the firm's centre of operations shifted to Herbert Street. The old premises, however, have continued to play a useful role in the town's life. George Damp & Sons established their engineering business here, and in 1932 were described as 'General smiths, oxyacetylene welders, engineers and hardware dealers (lawn mowers a speciality)'. The three Damp brothers (Sid and his identical brothers Bert and Jack) were keen members of Leyland Photographic Society, who in 1963 produced *Focus on Leyland*, perhaps the finest cine-film made about the town. Since Sid and the Damp twins retired in 1980, the property has continued, as ever, to be home to useful sales and service facilities of all kinds.

LEYLAND MOTORS: HERBERT STREET WORKS

GHOSTS IN THE camera: the Leyland Steam Motor Company, *c.*1900. In 1880 James Sumner and his younger brother William produced their first steam wagon for John Stanning's bleachworks. James took over the family business in 1892, and James Sumner Ltd was formed in partnership with the Coulthard's foundry. When the Preston firm was taken over, the Spurrier family began to take an interest. In 1896 Henry Spurrier II joined the Sumners, the Red Flag Act was repealed and

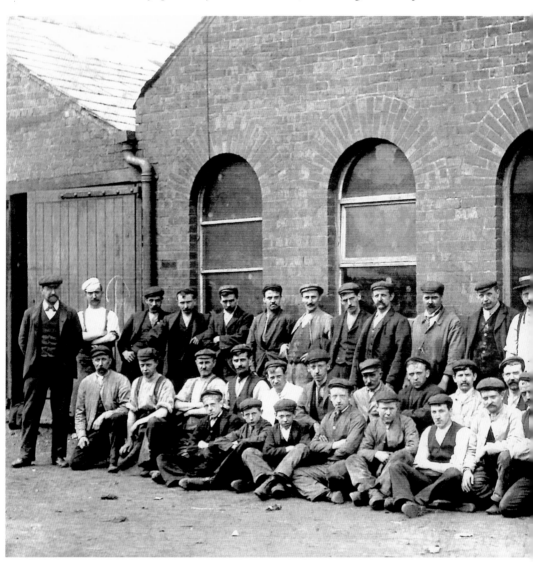

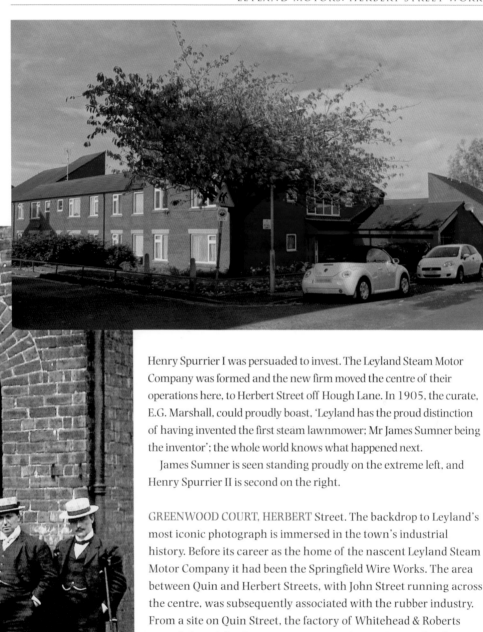

Henry Spurrier I was persuaded to invest. The Leyland Steam Motor Company was formed and the new firm moved the centre of their operations here, to Herbert Street off Hough Lane. In 1905, the curate, E.G. Marshall, could proudly boast, 'Leyland has the proud distinction of having invented the first steam lawnmower; Mr James Sumner being the inventor'; the whole world knows what happened next.

James Sumner is seen standing proudly on the extreme left, and Henry Spurrier II is second on the right.

GREENWOOD COURT, HERBERT Street. The backdrop to Leyland's most iconic photograph is immersed in the town's industrial history. Before its career as the home of the nascent Leyland Steam Motor Company it had been the Springfield Wire Works. The area between Quin and Herbert Streets, with John Street running across the centre, was subsequently associated with the rubber industry. From a site on Quin Street, the factory of Whitehead & Roberts spread along John Street into Newsome Street. As Wood-Milne, the firm pioneered the use of rubber in shoes. They became a part of British Goodrich in 1924, which duly morphed into the British Tyre & Rubber Company in the 1930s. The Herbert Street site became a rubber warehouse, and the Quin Street site was taken over by Iddon Brothers. The street plan of this most interesting quarter is little changed from a hundred years ago. Greenwood Court, seen above, now occupies this site.

LEYLAND MOTORS, HOUGH LANE

HOUGH LANE: A residential and manufacturing district, c.1905. Hough Lane emerged as a principal thoroughfare quite late on: previously it had been little more than 'the way to Ralph Leyland's tenement'. Development along the north side proceeded first. By 1905 Whitehead & Roberts had their Ajax rubber works on Quin Street, which in 1907 expanded to become Wood-Milne. In 1902 work began on what was to become the Motors' North Works; five years later the name 'Leyland Motors' was adopted, and in 1908 development to the South Works began.

By 1920, enormous but distinctive vehicle production shops straddled Hough Lane, and many of the high-quality garden-fronted houses were adapted to serve the army of workers which daily descended upon it.

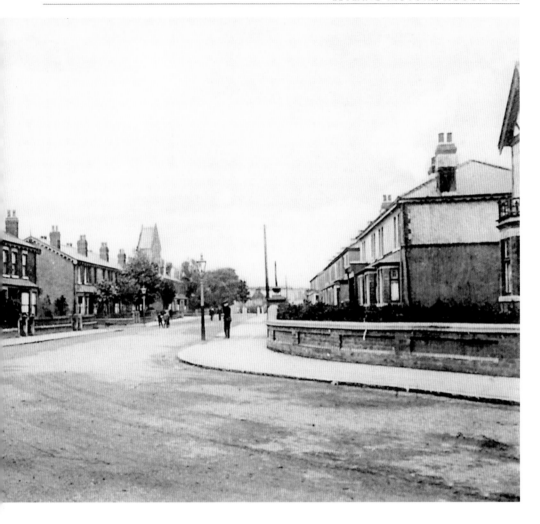

David Grant's splendid United Reformed church towers over the scene and other traces of a prosperous and optimistic past still lie in its architectural detail today.

HOUGH LANE: LEYLAND'S most popular thoroughfare. With the growth of the Leyland factories, Hough Lane initially developed to provide high-quality accommodation. The daily needs of the workforce provided a ready market and properties were converted into shops. In this piecemeal way, a shopping area developed. After 1950, planners thought in terms of a single large town-centre development, to be located in Southern Towngate. Development along Hough Lane was to be held back: properties were too small and hemmed in by the factories.

The closure of the North and South Works in the 1980s and the changing needs of shoppers led to a rethink by 1995. The town would support two centres, and with the completion of the Tesco store resources were directed towards Hough Lane, Chapel Brow and the former Gas Works site between. Car parking was extended, the new market opened and footpaths were improved to establish Leyland's most popular thoroughfare.

LEYLAND MOTORS: NORTH WORKS

THE MAIN ENTRANCE to Leyland Motors Ltd, and the Leyland Gates, Northcote Street, *c*.1965. Hough Lane was the centre of the company's operations until it was overtaken by the Farington site, where development began in 1913. Leyland Motors (1914) Ltd had a workforce of 1,500 and a capital of £400,000. Their first exports went to Ceylon in 1901, and amazed local troops encountering the steam wagons during the Second World War found them to be in fine fettle. For over a generation almost anything that could be made out of metal might be manufactured off Hough Lane. In 1920 it was announced that 'Mr Henry Spurrier, our managing director, has personally received King George V's new Royal Appointment for the company as manufacturers

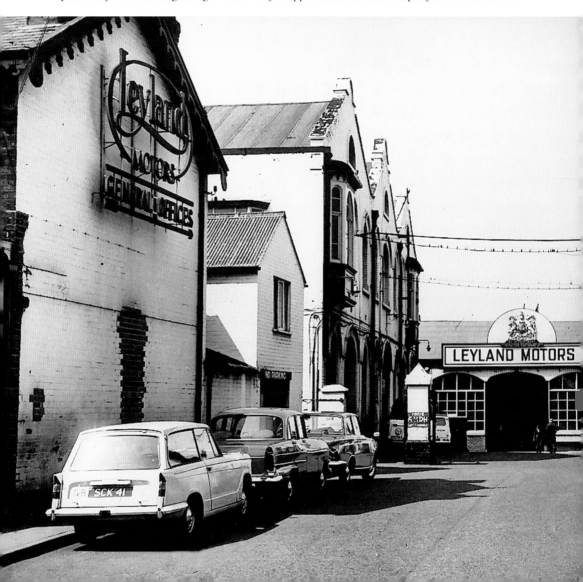

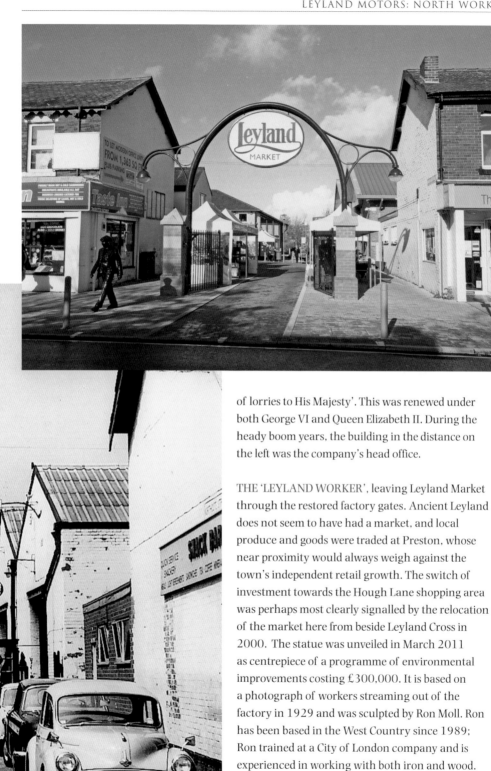

of lorries to His Majesty'. This was renewed under both George VI and Queen Elizabeth II. During the heady boom years, the building in the distance on the left was the company's head office.

THE 'LEYLAND WORKER', leaving Leyland Market through the restored factory gates. Ancient Leyland does not seem to have had a market, and local produce and goods were traded at Preston, whose near proximity would always weigh against the town's independent retail growth. The switch of investment towards the Hough Lane shopping area was perhaps most clearly signalled by the relocation of the market here from beside Leyland Cross in 2000. The statue was unveiled in March 2011 as centrepiece of a programme of environmental improvements costing £300,000. It is based on a photograph of workers streaming out of the factory in 1929 and was sculpted by Ron Moll. Ron has been based in the West Country since 1989; Ron trained at a City of London company and is experienced in working with both iron and wood.

27

AN INDUSTRIAL LANDSCAPE

INDUSTRIAL LEYLAND: LOOKING north-east from the roof of the town post office, 1935. Leyland Gas Works dominates a heavily-polluted industrial scene, with the spectacular chimney of Farington Mill on the skyline. Between the wars this was the industrial sector, far removed from the tranquil centre, with its public buildings clustered around Leyland Cross. The early centre of the rubber industry was here, and the North and South Works were little more than a large manufacturing plant, with Hough Lane running between them, and Brook Mill and the main West Coast railway

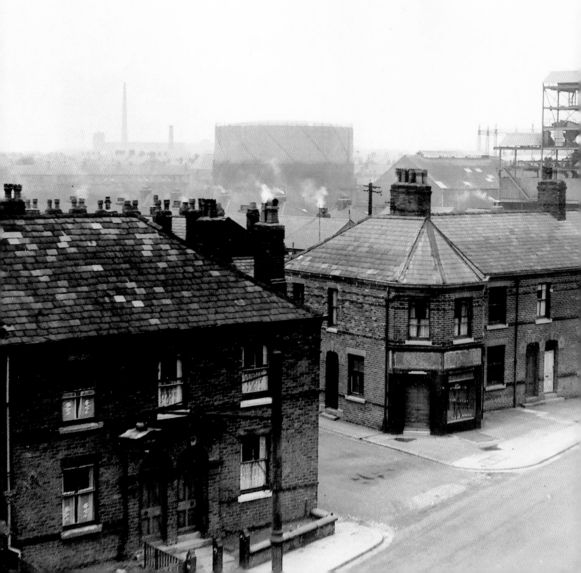

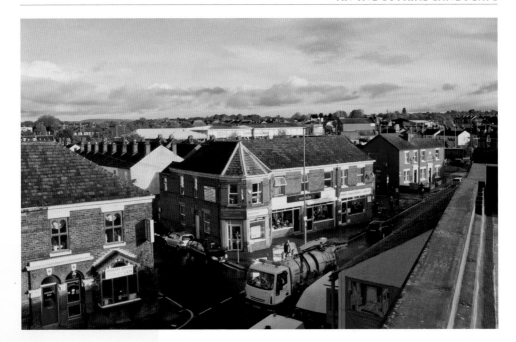

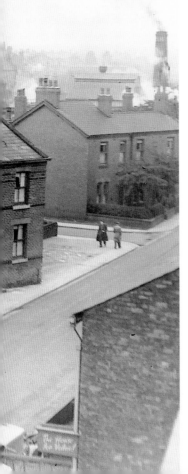

line only a short distance away. No wonder that local attics were notorious for their depth of sand, soot and other airborne pollutants.

What earthquake would be required to remove all the factories, bring gas from deep under the North Sea, hundreds of miles away, produce electricity cleanly and transform this into the town's favourite shopping area?

RETAIL LEYLAND: LOOKING north-east from the roof of Weatherspoon's 'Leyland Lion', October 2011. This photograph shows the reality of improved air quality: the morning sun can be seen on a clear autumn day, as a low pressure system coming off the Irish Sea passes above the town and in the distance rises over the Pennine foothills. The old intensely industrialised inner sector of the town has been removed and a grotesque Lowry landscape is transformed, creating a cleaner environment than the town has enjoyed for perhaps 120 years. The Gas Works ('Leyland Perfumery') and Farington and Brook mills (closed in the late-1960s) and their myriad chimneys are gone. Today the retail and leisure sectors dominate the modern townscape, epitomised by the redevelopment of the former Gas-Works site in the late 1990s, and earlier reversal of 1970s planning policy to create the long awaited new 'town centre', not by Leyland Cross but in the Hough Lane-Chapel Brow area. The art-deco former post-office building opened as a popular eating establishment in 2011.

LEYLAND MOTORS,
SOUTH WORKS

AIR PHOTOGRAPH, HOUGH Lane, *c*.1935. The South Works are at the top, and the North Works can just be seen at the bottom of this photograph. From the air, the scale of the industrial development of Hough Lane is very clear. The Congregational (United Reformed) church is a

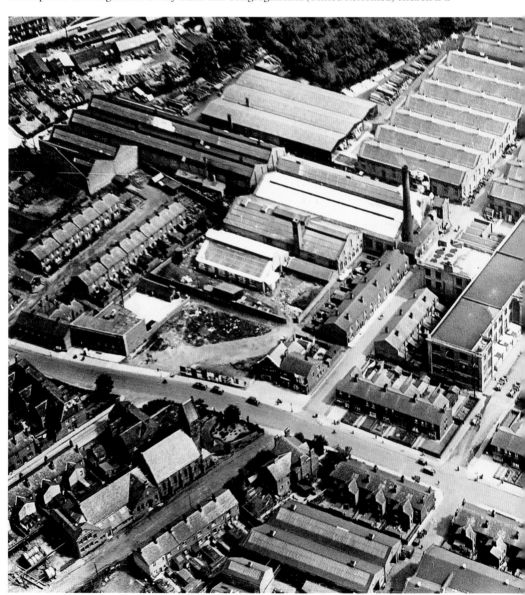

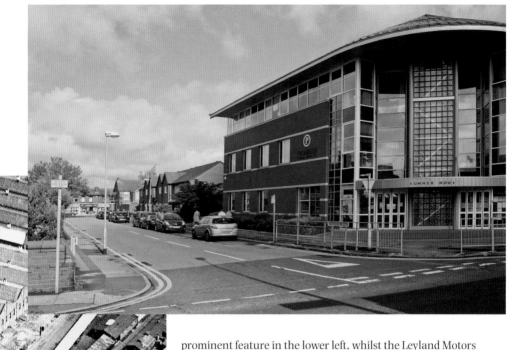

prominent feature in the lower left, whilst the Leyland Motors canteen building on Thurston Road dominates the scene.

Along Hough Lane the *new* post office (another fashionable art deco building) can be seen on the far left. Building along Hough Lane is incomplete and many of the houses still retain their colourful front gardens. At the far end of Thurston Road, work on the future British Commercial Vehicle Museum building had yet to begin.

THE MODERN PHOTOGRAPH shows Sumner House, on the former Leyland Motors' canteen building site, Thurston Road. The concentration of production at the Farington Assembly Plant brought production at the North and South Works to an end. These enormous sites were then redeveloped for domestic and retail use. Thurston Road had been dominated by a spectacular early art-deco three-storey concrete building, which served as the works' canteen and was big enough to feed a large proportion of the workforce at a single sitting. The top floor became the drawing office and many of the company's world famous products were created here.

Having been derelict for seven years, the building was demolished in 1995, and work began on a three-storey building for the New Progress Housing Association and a small development of family houses. The complex cost over £1 million, and Sumner House was opened in 1996.

MASS
PRODUCTION
AT LEYLAND

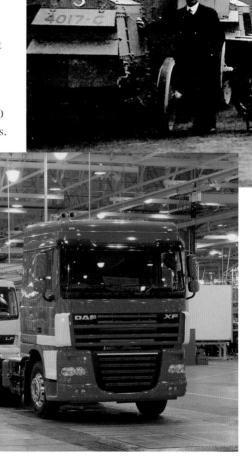

HENRY SPURRIER II shows off wartime
production in Northcote Street, 1915. The two
world wars were deciding factors in the rise of
local industry, especially of Leyland Motors. The
War Office placed 'colossal orders' in 1912, and
with 1,500 employees the company was reformed
as Leyland Motors (1914) Ltd. Prior to this it
boasted of having produced 2,000 vehicles, but
in 1914-18 it turned out three times as many.
Even this paled in comparison with the boom
during the Second World War; male employment
rose from 6,500 to 9,000, and large numbers
of women found work, their number rising from
500 to 3,000. Though the plants were bombed
on a number of occasions, they turned out 3,000
tanks, 10,000 vehicles, and 10,000 tank engines,

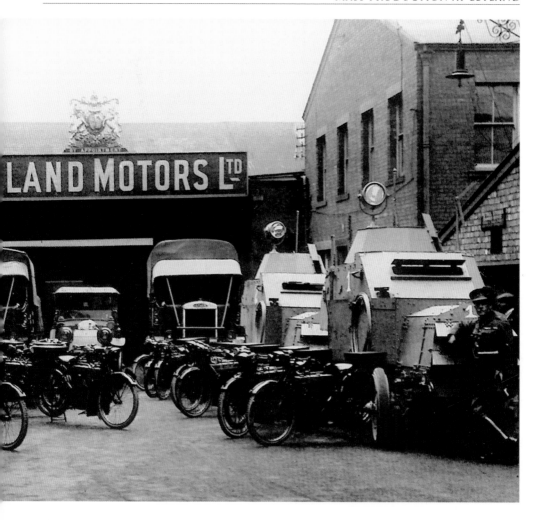

as well as 11 million bombs, and 5 million shells. The Korean War led to the development of the enormous Farington tank factory, after 1956 the Spurrier works.

THE LEYLAND ASSEMBLY Plant, May 2011: a run of vehicles at the end of the assembly track. In contrast to pre-1975 production, these vehicles have not been made in Leyland; in common with most manufacturers today, the vehicles have been assembled from components made in a number of countries. Seen here in a spotless environment are vehicles in the DAF range of vehicles. Under the Just In Time system (Jit), components are fed into the line enabling a range of models to be built simultaneously. Here the red and blue trucks are articulated six-wheelers, the largest in this range. Engines are built either by DAF in Eindhoven or by Cummins in Darlington, and cabs at Westerlo in Belgium. The yellow and purple vehicles have Darlington engines but cabs built in France by Renault in Blainville, near Caen. The computer-controlled system is infinitely variable, empowering a workforce of less than 1,000 to produce twenty-five times their number of trucks.

(Courtesy of Leyland Trucks Ltd)

'INTERESTING TIMES'
AT LEYLAND MOTORS

THE COMET TRUCK assembly line, BX Factory, Farington, 1950. With the council's symbolic acquisition of Worden Park in 1951, there seemed to be no limit to what might be achieved as Leyland Motors drove the town's economy forward. The Korean War led to the creation of the government Tank Factory, which became the Spurrier Works in 1956. Booming employment opportunities in what was known as the 'Leyland Employment Area' thus underpinned the New Town philosophy.

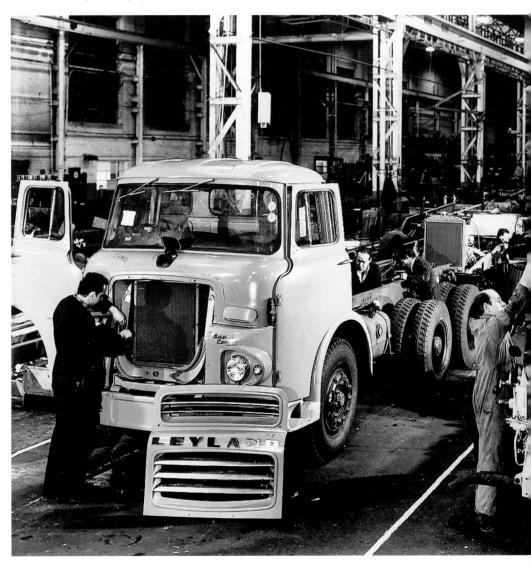

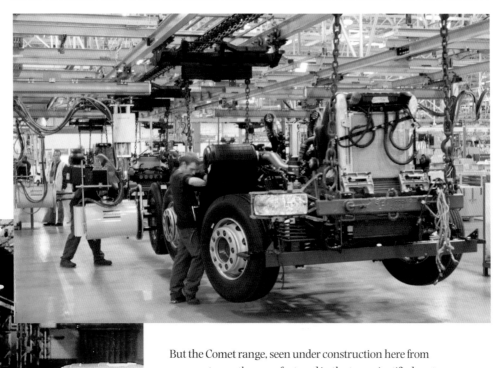

But the Comet range, seen under construction here from components mostly manufactured in the town, justified post-war optimism, and the firm did continue to expand spectacularly both at home and abroad for another twenty years. The future never seemed so assured as when Harold Wilson opened the residence for premium apprentices, Stokes Hall, in September 1965. In the event, changes in the balance of global trade abroad, and mismanagement by the usual suspects at home, meant Leyland was in for some interesting times.

DAF MODELS ON the assembly Line, Farington Assembly Building, summer 2011. Extricating 'Leyland', which so recently as 1968 had employed 13,000 people in the town, from the wreckage of British Leyland was painful. Bus and truck divisions were established in 1981. Leyland Bus, the subject of a 'management buy-out', was bought by Volvo in 1988 and most production ranges were ended. In 1987 the Truck Division merged to form Leyland-DAF. When DAF failed spectacularly in 1993, 'Leyland' was subject to a staff buyout and five years later was taken over by Paccar. Based here at the Leyland Assembly Plant, the business is now a profitable subsidiary, the lone survivor of over twenty British manufacturers – though sadly the much-loved 'Leyland' badge has not yet been revived. The collapse of DAF released important land holdings in the town for future development, from which modern Leyland has emerged.

(Courtesy of Leyland Trucks Ltd)

LEYLAND FOR ALL TIME

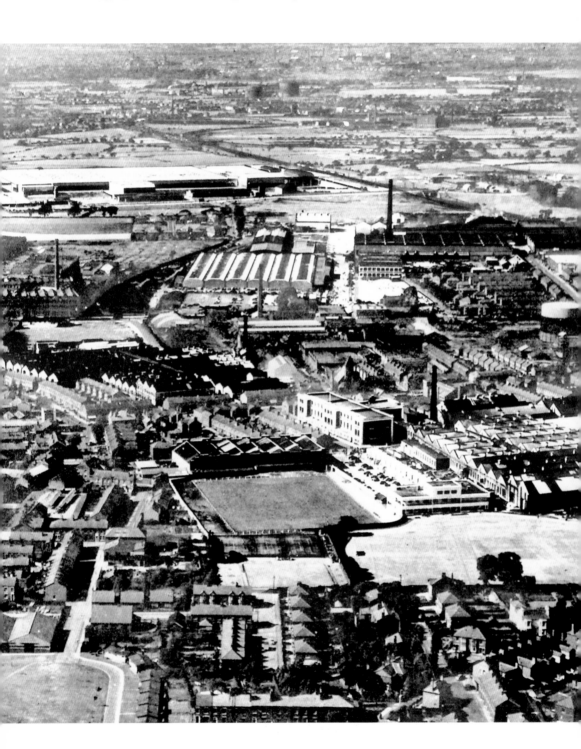

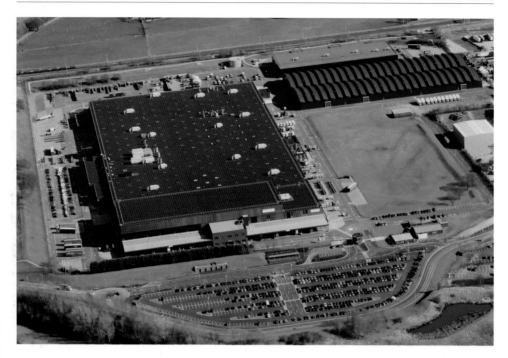

THE LEYLAND MOTORS factories, *c.*1955. This publicity photograph originally hung in the firm's Canadian offices. It highlights the company's premises. From the bottom up: the sports grounds, South Works, Thurston Road, (Hough Lane), North Works, (Golden Hill Lane), the Farington Works, and Spurrier Works. Other interesting details include the Leyland & Birmingham factory and the Gas Works and Farington Moss, stretching away into the distance. These were golden years for the company; Albion Motors was acquired in 1951 and the Leyland Atlantean double-decker entered service in 1958. The Leyland Motor Corporation was formed in 1963; Sir Henry Spurrier retired and Donald Stokes took over. In 1968 the profitable bus and truck business merged with the 'desultory' British Motor Holdings to become, briefly, the fifth biggest vehicle producer in the world, employing 200,000 people. British Leyland Ltd, formed by a massive government bailout in 1975, could not prevent the collapse of the British car industry but did provide funds for the new Leyland Assembly Plant.

ONE OF EUROPE'S most advanced truck assembly factories: the Leyland Assembly Plant, pictured in May 2011. This cavernous structure was opened in 1980 at a cost of £33 million. It was created to build the successful T-45 series and saved truck making in Leyland. Closure of the North and South Works followed and the components were no longer made in the town. The 'Jit' method delivers components directly onto the assembly line. The results are impressive. Leyland Trucks are a major subsidiary of Paccar, with Leyland their 'centre of light and medium truck design, development and manufacture in Europe'. All the right-hand variants of the range are built here and 40 per cent of production is exported. Leyland is, therefore, still an internationally important producer of trucks. Within two years, the millionth vehicle to be made in the town since 1896 will drive off the assembly line in Farington.

(Courtesy of Leyland Trucks Ltd)

DAVID GRANT'S HOUGH LANE

HOUGH LANE, C.1959: the end of Wellington View, the semi-detached houses Lily and Spring Bank, and David Grant's church. These buildings were the work of the leading local Nonconformist architect David Grant. Born in Scotland in 1846, he was commissioned in 1874 to design a new congregational church to be sited on the corner of Quin Street and Hough Lane. Mr McMinnies, manager of Farington Mill and resident at Farington Lodge, laid the foundation stone in May 1876, and the church was opened on 12 October 1877. Constructed from Padiham stone in a very restrained Early Gothic style at a cost of around £5,000, the church and parish rooms would seat almost 500 people and have a tower 80ft high. David Grant also designed the semi-detached houses to the left of the church, Lily Bank and Spring Bank – a pair of extremely fine houses. He married

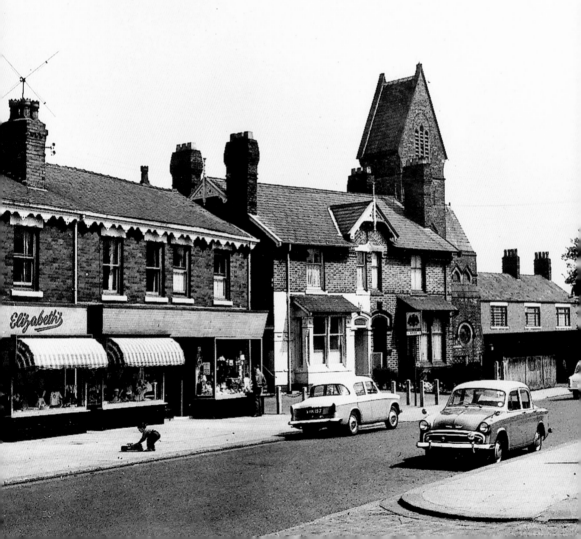

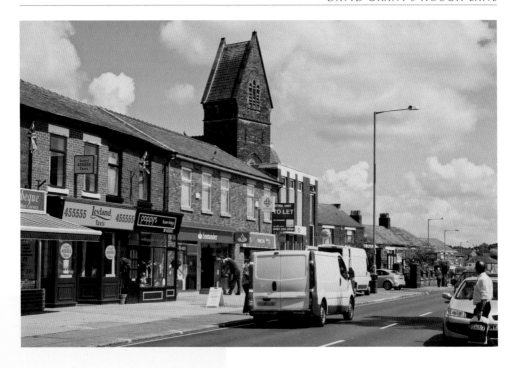

Elizabeth Anderson, the couple had three children and the young family lived at Lily Bank.

THE NORTH EAST corner of Hough Lane. The transformation of houses along Hough Lane into retail outlets, a process already apparent between the wars, is now complete. However, traces of David Grant's architectural influence as Leyland emerged as an industrial powerhouse in the late nineteenth century can still be found. Sadly, Lily Bank and Spring Bank with their colourful gardens are long gone, having been transformed into financial agencies. Indeed, it raises the question of what Grant – an agent of the Leyland & Farington Building Society – might have achieved with domestic housing had he not taken his family to Australia, for in the twentieth century Leyland was to become the province of the semi-detached house.

Here, amidst the town's bustling new centre, the site is surely worthy of a Blue Plaque, for Spring Bank was the home of James Sumner's 'partner' Henry Spurrier II, whose son, Sir Henry, was born here.

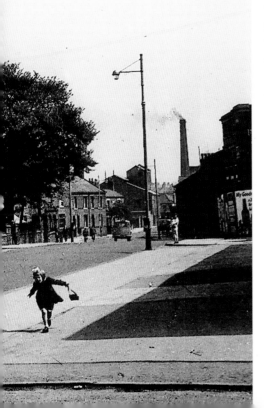

CHAPEL BROW

THE METHODIST CHAPEL (1814), Chapel Brow, *c*.1900. Chapel Brow emerged as a bustling centre of shops and public houses serving the local factories and the adjacent railway station. Leyland Gas Works ('Leyland Perfumery') stood behind the houses on the left and Brook Mill was similarly situated off Orchard Street on the right. Opened by Read & Wall in 1870, the 1,000-loom mill took its name from the Bow Brook, which, flowing west, passes under the road here to emerge as Bannister Brook.

Anthony Hewitson described the locality in the early 1870s:

> *The principal Dissenting place of worship in Leyland belongs to the Wesleyans. It is called Golden Hill Chapel. Gas, cotton, steam, railway wagons, and drink, five of the most certain coinmaking*

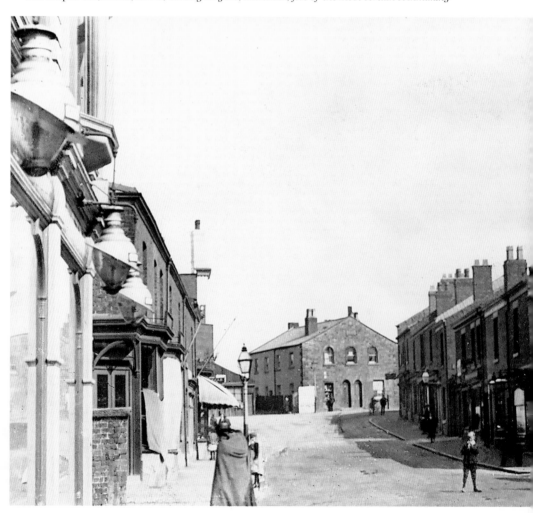

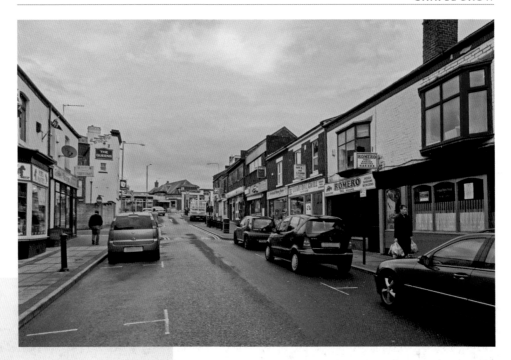

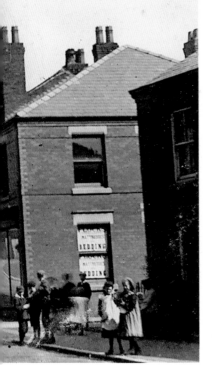

articles known, in fair weather, enter into the business of the immediate locality.

The chapel he found to be 'a small, stiff, strong, stone building, like a respectable barn with windows'.

BUSY CHAPEL BROW. By the mid-1970s, town planners saw development along Hough Lane and Chapel Brow as secondary to the Southern Towngate project. Indeed, retail outlets along Chapel Brow were to be discouraged. Twenty years later this policy was reversed: 1960s-style shopping centres were out of fashion – two clusters might suit the town better. The removal and reclamation of the former Gas Works released a large site with good road access for development. As the Metrolands development floundered, events here moved on rapidly: in May 1998 McDonald's applied for planning permission for a drive-through restaurant seating seventy-five, and Lidl supermarkets were also showing interest. In January 1999 patrons anxious to take advantage of an offer of 'free Macs' overwhelmed the restaurant. The retailer Pound Stretcher was to move onto the site and in August 2000 the retail development was extended. Chapel Brow now took its place as Leyland's centre for dining and entertainment.

TURPIN GREEN LANE

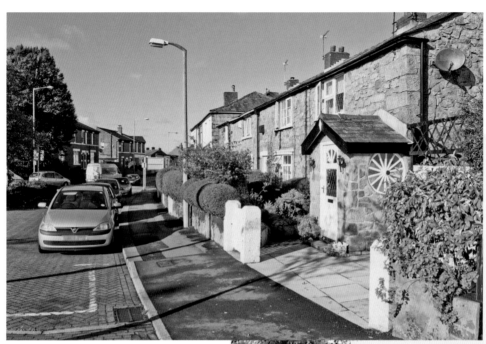

TURPIN GREEN LANE, *c*.1920. Before industrial development Chapel Brow, Golden Hill Lane, Bow Lane and Turpin Green Lane encircled a very fertile area of land with Bow Brook/Bannister Brook flowing through it. In the seventeenth and eighteenth centuries this small estate was owned by the Fleetwood family. Their hall stood in the north-west corner (Fleetwood Street). Though easily overlooked in the road system that has overwhelmed it, Turpin Green Lane was originally an important part of the network of paths and lanes that enabled the townships to the east to exploit the fuel reserves of peat on the western mosses. Accordingly the origin of the 'Turpin' element in the place name is derived from 'turf pit', and appears as 'Turpett Moore enclosure' in 1607.

With its pleasantly rolling countryside leading onto the great primeval mosses this must have been a particularly attractive locality.

TURPIN GREEN TODAY. Few parts of the old village have been so radically transformed by the needs of the motor car. The east end of the 'lane' is taken over by the eight-lane M6 motorway and the very large access points, whilst this area is dominated by the £4 million King Street Link opened in 1993. The result is the four-road double roundabout system opposite the Ivy Cottages seen in the picture. This is now one of the busiest road junctions in Leyland, ironically part of a road system that seemed to have been made redundant by the closure of the large industrial plants along Golden Hill Lane, but now links the large retail stores and housing developments that – in just twenty years – have replaced them.

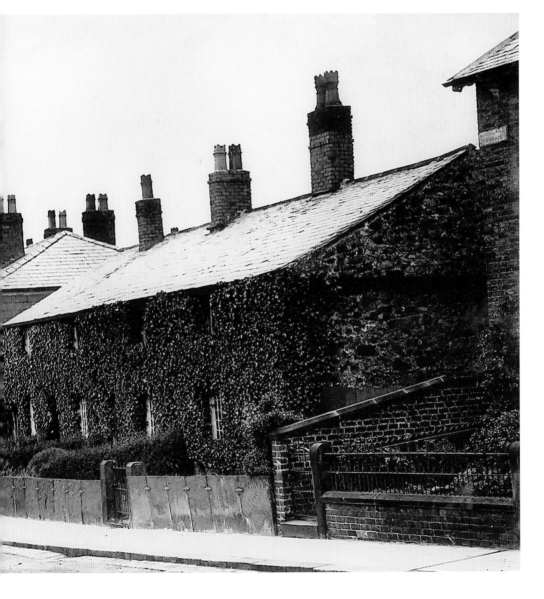

LEYLAND'S CENTRAL PLACE

LEYLAND PARISH CHURCH, seen from the Vicar's Fields, *c.*1900. The Vicar's Fields were a remnant of the medieval church lands. Eilert Ekwall took the place name to be derived from the Middle English *Ley-land* or *fallow*, meaning unploughed land. The church building occupied a prominent, carefully chosen site, and the tower affords a wide panorama of 'Leylandshire'. A web of ancient paths radiated out from the church in all directions. The sandy path seen here begins by the churchyard gate (by the museum) and runs due south to Holt Brow. The Worden Hoard of over 100 third-century Roman coins was found in the vicinity of this line. The Leyland cricket team played early matches here in May 1848: 'The towering canopies of majestic beech

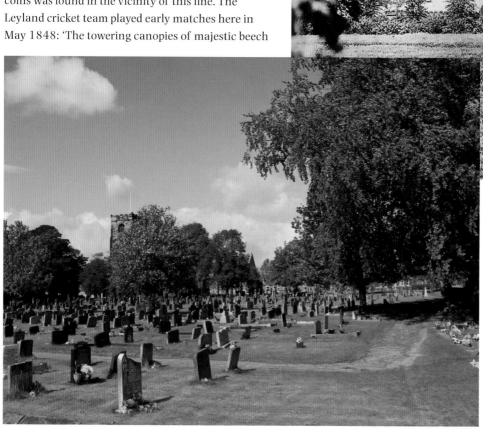

trees which flank the vicarage grounds basked in ethereal splendour and overshadowed the living current of spectators. Leyland went in first.'

ST ANDREW'S CEMETERY. During the twentieth century, the fields came under intense pressure from the need for burial space and housing development. The small churchyard with its lime trees began to expand in the nineteenth century. The extension to the west of the tower dates from the 1840s, that to the east of the path from forty years later. Thereafter the southern edge was pushed back in a series of shifts and today the cemetery is nearly full.

The original lime trees, replanted in the 1940s, have grown well and the small scale of the old churchyard can be appreciated. It was notable for a wonderful show of crocuses, still seen in springtime behind the Eagle & Child. The area is a haven for plants and wildlife, and for a time recently marked the northern frontier of invading ladybirds. How many people are buried here is uncertain, but over a millennium 15,000 might not be an exaggeration.

CHURCH ROAD

THE METHODISTS' WHITSUNTIDE procession, Church Road, 1931. Inspector Ripley leads the walk as it approaches Leyland Cross. Building along Church Road was continuing at this time, and the houses at the end of Sandy Lane and across from the churchyard can be seen. The elevated position of the church is very apparent and the line of lime trees that fringed the northern side can be seen. The site on the corner with Towngate was occupied by Heaton's ironmongers shop, and part of the stock of chimney pots at A.M. Tomlinson's builders can be seen behind it. This was one of a number of three-storey brick-built buildings erected around the Cross that were such a graphic illustration of the village's growing prosperity around the turn of the eighteenth century.

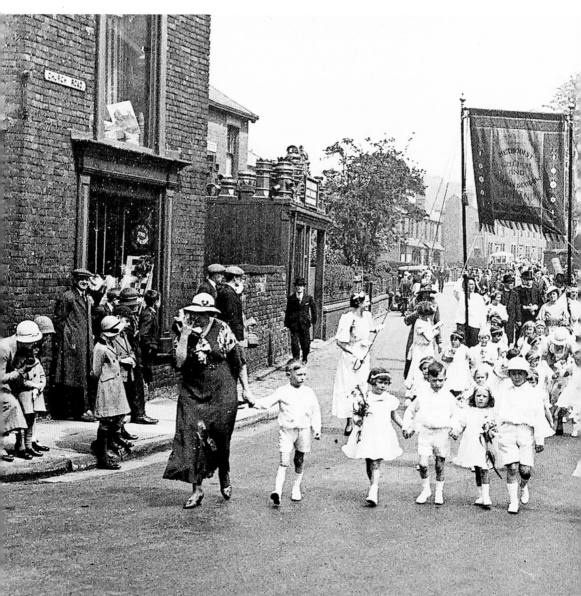

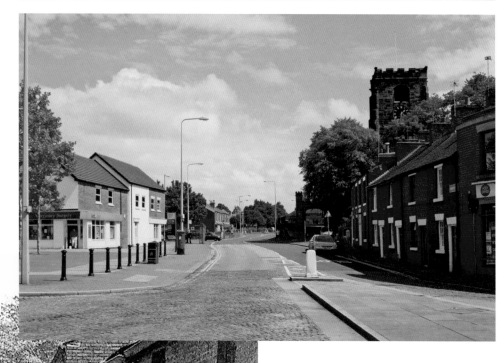

THE VIEW LOOKING up Church Road from Leyland Cross. The effects of the wholesale removal of the village centre can be graphically seen here. Ironically, they have had the effect of accentuating the church's prominent position, and the old Free Grammar School may just be glimpsed through the churchyard arch. Demolition of the Heaton's building opened up the area around the Cross, creating a permanent site for the town's open-air market as a part of the 1960s Metrolands development. To this end, a number of small shops and offices were set back to adjoin two large stores.

To facilitate these developments, important changes were made to the road layout. Traffic along Worden Lane and Towngate was closed off, leaving Leyland Cross sentinel over a sharp curve in the east-west route. When St Andrew's Way was created, the junction was moved 200yds to the east, with the north and south entrances controlled by traffic lights.

47

LEYLAND WAR MEMORIAL

UNVEILING OF THE Leyland War Memorial, Church Road, 9 November 1929. The memorial was built in 1929 on a plot of land given by the council. The preparatory work was undertaken by volunteers, mainly ex-servicemen, and the memorial itself was made out of Creetown granite. The cost of £1,295 was raised locally from whist drives, dances, and door-to-door collections and the various factories contributed.

The ceremony was led by Major W. Jervoise Collas of the Loyal Regiment, based at Preston, and featured Mr Charles Porter, a local man who had been blinded in the war. The Bishop of Whalley dedicated the memorial, and on a day of strong wind and heavy rain the townspeople of Leyland turned out in great numbers to pay their respects to the 195 men whose names are on the memorial. The extensive open space which still lay behind the frontage of shops on Towngate can be seen behind the memorial.

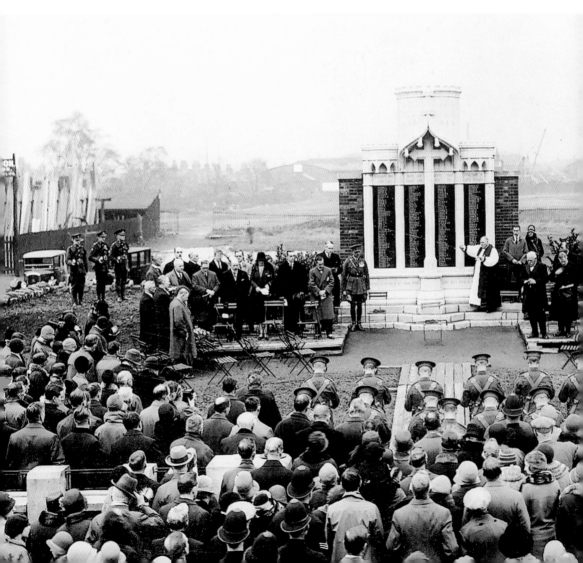

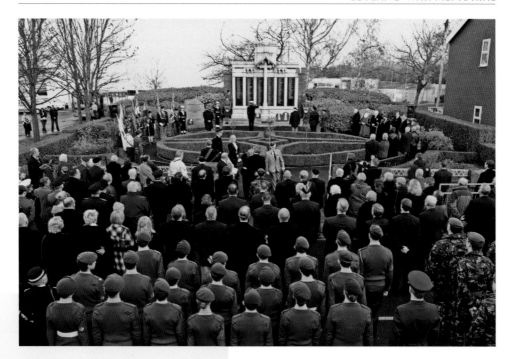

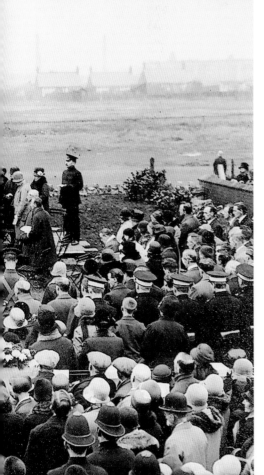

THE LEYLAND MEMORIAL GARDEN. The *Leyland Guardian* reported the dedication of the Second World War extension on Sunday 16 September 1951:

Councillor F. Marsden, Chairman of the Leyland Urban District Council, pulled two white cords, and the Union Jacks that shrouded the names of 74 men who died in the last war fell away. In a moving service, witnessed by nearly 1,000 people, the Rev.L.C. Peto, Vicar of Leyland, dedicated the extension to Leyland war memorial.

The unveiling was preceded by a procession round Leyland, comprising dignitaries and representatives of the three services. At the end the procession re-formed, about 500 people in all. They passed the Cross and the crowd lining Towngate, where Councillor Marsden and senior officers took the salute.

Recently, another memorial of natural granite has been erected, which now has plaques affixed that bear the names of men who died in operations since the Second World War.

LEYLAND FREE GRAMMAR SCHOOL

THE OLD GRAMMAR SCHOOL, Church Road, Leyland, *c.*1910. When Henry ffarington
established his chantry in the parish church in 1524 the priest was to maintain a 'skole' there.
Reformed around 1580, the structure seen here comprises two buildings, the late sixteenth
century timber-framed school (seen on the left) and an adjoining master's house erected in
1790. The list of teachers is fairly complete, and in the absence of provision for their retirement
three poorly paid men served 145 years between them (1716-1829): Thomas Moon (66 years),
Edward Marsden (56), and John James (29). The school closed in 1874 but the endowment was
transferred to Balshaw's where it survives as a school prize. The building was duly purchased for

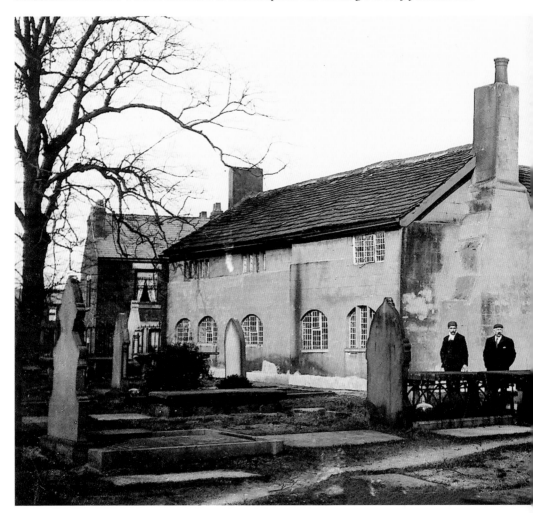

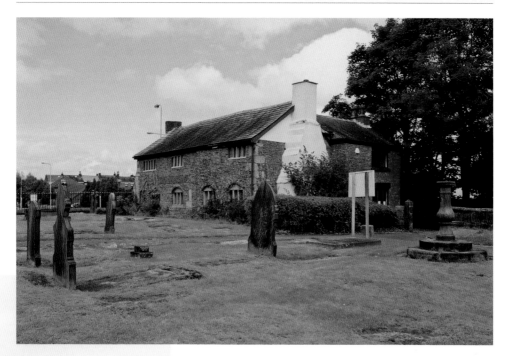

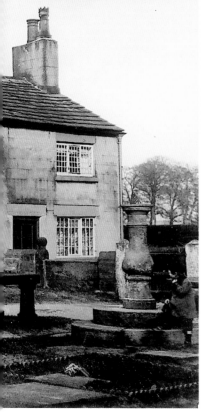

the church that used it for storage and meetings: the teacher's house and upper rooms were let as accommodation. John Berry, aged 30, 'order clerk', was resident in 1891 and gave his address to the census as 'Grammar School House'.

A COMMUNITY'S MUSEUM. When the final residents left in the early 1960s, the building was wholly abandoned and the windows bricked up to deter vandals. Amidst plans to demolish it to make way for a car park, the fourth oldest grammar school in the county was bought for £1, on condition that the building was restored. Work was underway by 1977 and the arts centre was opened in December 1978. Local groups had been important contributors to the fight to save it and many local people now volunteered to work at what became South Ribble's Museum & Exhibition Centre, attracting around 5,000 visitors a year. In recent years important exhibitions have included the Royal Geographical Society's 'Shackleton' in 2007 and 'Everest' exhibitions, 2008; the first presentation of a Royal Society summer exhibition outside of London, 2009; and the Worden and Cuerdale Hoards, 2011. The museum is open on Tuesdays and Fridays, 10-4 p.m., Thursdays, 1-4 p.m., and Saturdays, 10-1 p.m. For further details, see southribblemuseum.org.uk.

LOWER CHURCH ROAD

CHURCH ROAD, C.1910. A fine panorama viewed from the east of the Eagle & Child Inn and the parish church. The stone barn on the right stood by what is now the junction with Balcarres Road, and the row of very old lime trees along the churchyard wall can be seen towering over the Old Grammar School. By 1910 the latter had closed: the teacher's house was tenanted and the schoolroom was in use for parish activities.

The present-day Eagle & Child inn dates from a small cottage erected in 1749 by the Critchlowe family on a field strip that lay along rising ground known as School Hillock, despite the opposition of

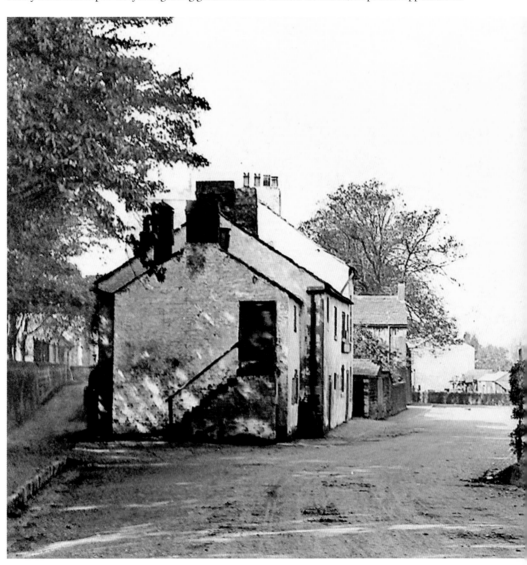

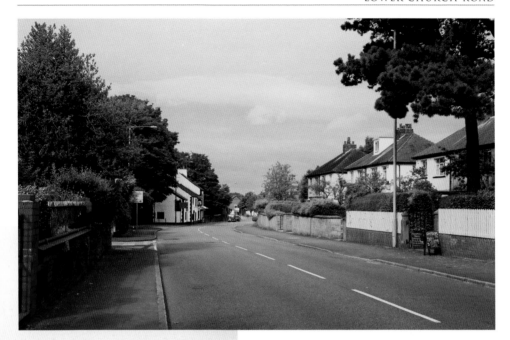

both the squire and the church vestry. The small inn was originally known as the Holy Lamb, and William Cooper was landlord in 1753. Though long supposed to have housed the village lock-up cells in its cellars, this cannot be confirmed.

THE BIGGEST CHANGE to the west end of Church Road came comparatively recently. The road originated as a sunken track, 'the way to church' for people living in Clayton and the more distant 'Moor Quarter' of the parish. In the nineteenth century the way was hedged with few houses between the Eagle & Child and Heald House. Work on Beech Avenue, seen to the left, was delayed by the First World War and really only got underway in the 1920s, and the semi-detached houses on the right were built in 1924. The stone barn was only demolished in 1970 to make way for a car park, and the gardens belonging to the houses on the right were shortened for road widening. Prior to this, Church Road had been very narrow at this point. The subsequent construction of St Andrew's Way in the late 1980s created the major road junction here.

LEYLAND MAY FESTIVAL

ALICE RYDING, QUEEN of the May, on her throne with attendants. Leyland May Festival Ground, Church Road, 1905. Leyland Festival is one of the town's best-loved events, but that hasn't made it immune from the general uncertainties of recent years. The first festival was organised by Leyland Baldwin in May 1889 as the Leyland May Festivities. In the years up to the First World War it became a major local 'event', and by 1900 the Festival Committee was renting the North Paddock on Church Road – subsequently the May Festival Ground. Having lapsed in 1938 it was revived for the Festival of Britain (1951) and centred on Worden Park. The 1960s and '70s were very successful years, and local businesses and groups competed to provide the most fantastic floats. The centenary and the Millennium were celebrated in some style, but thereafter the event lapsed. Since 2010 efforts have been made under the auspices of

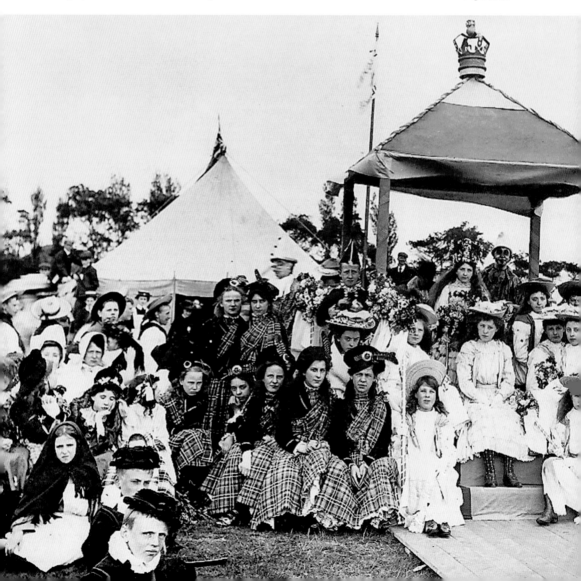

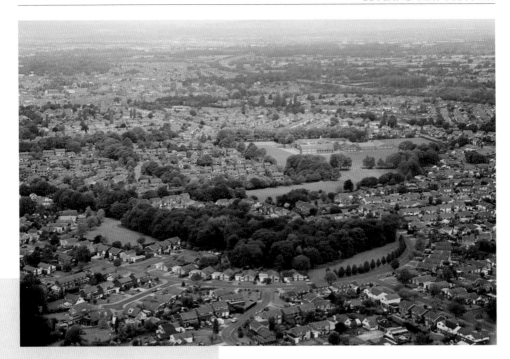

the Commercial Vehicle Museum and other interested parties to modernise and revive the festival.

LOOKING NORTH OVER Leyland: Dalehead Road, the former Leyland May Festival Ground and Balshaw's High School seen from above Langdale Road. The middle distance here is dominated by Balshaw's School and Church Road. To the west, North Paddock has been developed as the Mayfield estate; to the east, the M6 and the West Coast railway rush by; and in the north, Brook Mill, Farington Mill and heavy industry are gone. The drives and avenues of the Worden estate in the foreground, developed from the mid-1960s, are models of modern low-density housing. With much of the fabric of the town built since 1970, Worden Park in walking distance and good road links, Leyland has a suburban air. As our old friend Anthony Hewitson remarked in the 1870s, 'No place do we know... where there are so many cottage gardens. We dare back Leylanders for gardening against all the known tribes of the earth.' Not the 'Garden of Lancashire' again, but perhaps moving in the right direction.

(Courtesy of South Ribble Borough Council)

55

'NEW LEYLAND':
A LAND FIT FOR HEROES

THE OLD PHOTOGRAPH shows Dorman's steel-framed 'concrete' houses of the Leyland Motors Housing Society Ltd under construction in Sandy Lane, Leyland, 1920. Wartime expansion produced a post-war housing crisis. In partnership with the local council, and with support of government grants, the society was to provide prefabricated homes to sell and the council homes

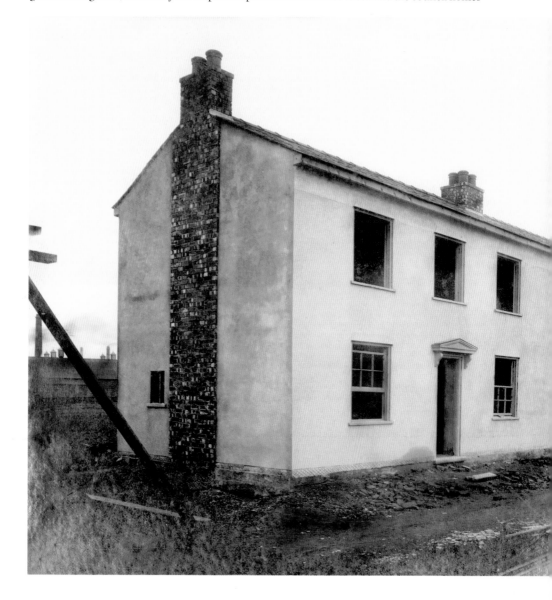

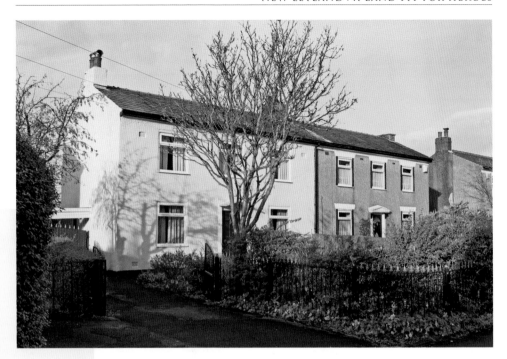

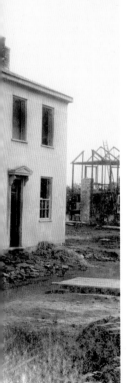

to rent in a very forward-looking scheme. The houses above were to have
one tenth of an acre and to cost £800 (less £300 government grant, a down
payment of £100, then payments of 80d per week). Electricity was provided
at 2d per lamp. Planning was on the grand scale: 'New Leyland' was to extend
north of Church Road, within the general sweep of Turpin Green Lane and the
railway. 'Broadway' was to link the factories and recreation ground at the west
end to planned shops, a school and a cinema at the east. Frequently unknown
to Leylanders, spectacular examples of these houses can be seen in Sandy Lane,
Sandy Place, and off Church Road at Claremont and Wellington Avenues.

(Courtesy of the British Commercial Vehicle Museum)

THE MODERN PHOTOGRAPH shows houses in leafy Sandy Lane. The post-war
boom was soon over and by 1923 the company's £1 shares had fallen to 13d.
Progress slowed. The cinema did not materialise but the facilities of the Social
& Athletic Club did. After the weaver colonies and the *ad hoc* provision of mill
housing, here is Leyland's first modern housing estate. Claremont Avenue is a
vivid icon of the art-deco styled Leyland of the 1920s, and the beacon of full
employment the town became in the difficult interwar years. The futuristic
concrete houses contain novel features, such as the ability to clean the chimney
from outside the house! Essentially 'privatised' today, company housing (seen here)
blended with council housing and privately-built properties, yet the company's
workforce was close at hand. Combining 'buy in 25 years', 'self buy and build'
and social housing, this very successful model is worthy of emulation today.

NEW INN

NEW INN, WIGAN Road, *c.*1905. This fine
three-storey house stood at the junction of Heald
House Lane, Dawson Lane and the Wigan Road. It
was built before 1725, possibly in the period 1710-15.
Large expansive houses such as this are typical of the
prosperous village in the early eighteenth century.
Once quite a common sight, they are now reduced to
the cluster around Leyland Cross. Built to replace Rose
Whittle's public house, and accordingly called New
Inn, it was a farmhouse and never sold beer!

In the eighteenth century Arthur Young described
the Wigan Road:

> *Let me most seriously caution all travellers who may*
> *accidentally propose to travel this terrible country,*
> *to avoid it as they would the devil, for a thousand to*
> *one but they break limbs by overthrows or breakings*
> *down. They will meet with ruts which I actually*
> *measured four feet deep, and floating with mud only*
> *from a wet summer!*

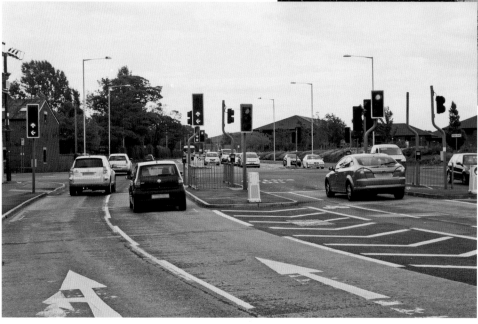

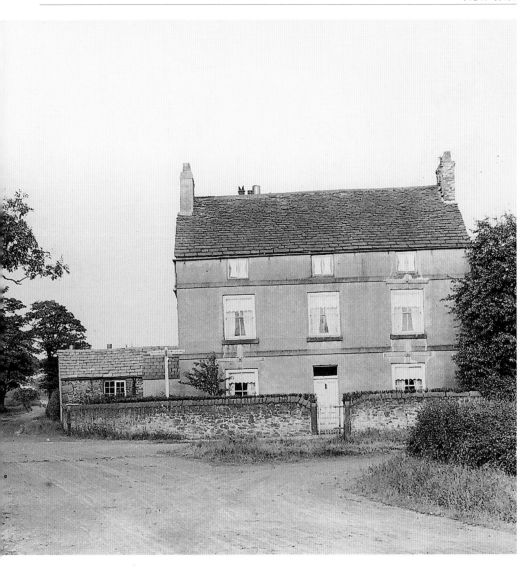

THE DAWSON LANE Junction. New Inn was demolished soon after the Second World War to improve access from Dawson Lane alongside the Royal Ordnance Factory. This huge 900-acre site was developed from 1936 around a core of the ffarington's Old Worden estate, and at its production peak employed almost 30,000 people.

The opening of the M6 through Leyland in July 1963 left the unregulated road junction largely unchanged until the traffic lights were installed at the start of the Buckshaw Village development on the former ROF site. Though an uninspiring sight today, this is nevertheless as historic a length of road as any in England. One of the main roads in the North-West, the line of the subsequent 'Wigan and Preston North of the Yarrow Turnpike Road' was traversed by Agricola's Roman legions, by Cromwell in 1648 and by Bonnie Prince Charlie's Jacobites in 1715. Today it is the more prosaic A49.

WORDEN OLD HALL

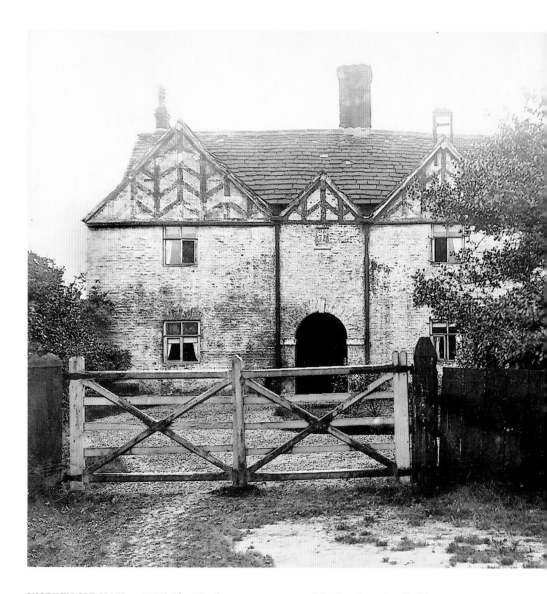

WORDEN OLD HALL, c.1895. The Worden estate was one of the first large landholdings to
emerge in Leyland. It was one of a parcel of estates granted to the crusader Knights of St John
of Jerusalem, though the sitting tenants continued undisturbed. From shortly after 1200 these
were members of the Anderton family, who lived here for 300 years until Henry ffarington
acquired it in the 1530s. Thereafter it was rebuilt and served as the family's main residence
until, following the death of William ffarington in 1715, Shaw Hall became the family residence.
To complicate matters they renamed Shaw Hall 'Worden Hall' in the 1840s. Their original home

– by then a farmhouse – has since been known as Worden Old Hall. When the War Ministry bought the estate for the development of the Royal Ordnance Factory it was virtually abandoned and public access denied. But it survived – just.

THE FRONT (NORTH side) of Worden Old Hall. As a prerequisite to the Buckshaw Village development, the hall was surveyed and restored, revealing it to be the remnant of a larger building. The main structure comprises seven bays, each around 10ft long, forming a building 66ft (20m) in length, 21ft (6.4m) wide and 30ft (9m) high. A bay is the area between two timber wall/roofing frames running across a building.

The north elevation had been extended, preserving the original highly decorated front walls and doorway inside. The internal structure was timber framed with staff and daub panels, resting on a stone plinth. Most of the timbers were well preserved and around thirty carefully knife-cut carpenters' numbers were found. Brickwork at the east end is perhaps the earliest in the county. Tree-ring analysis revealed a great deal of building activity around the middle of the sixteenth century, and tree-felling dates of 1538-53 reflect the rebuilding and home improvements undertaken by the ffaringtons.

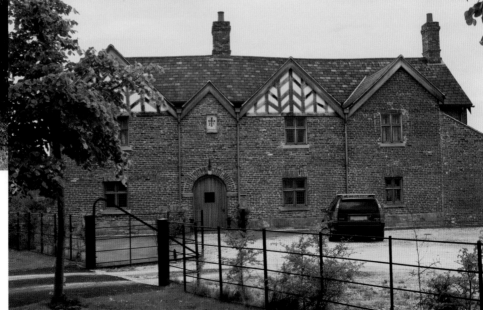

THE WAY WEST FROM LEYLAND CROSS

FOX LANE, C.1905. Fox Lane was formerly called Union Street at the Leyland Cross end, and Brook Street at the Seven Stars end. It was a country lane prior to post-1930 development, and in 1905 there were no buildings between Lower House Farm and the most westerly almshouse. Lower House was a valuable ffarington holding, particularly noted for the farmer's wife's speciality – cheese. In the days when cheese was made from a farm's own milk, a very subtle range of flavours could be achieved. At the Leyland Agricultural Show of 1855 the tenant, Jonathan Swann, won the prize for the Best Cultivated Farm: 'He has 14 acres of wheat', the

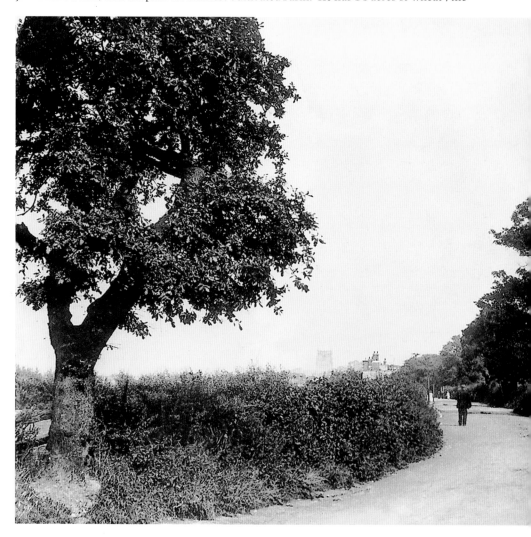

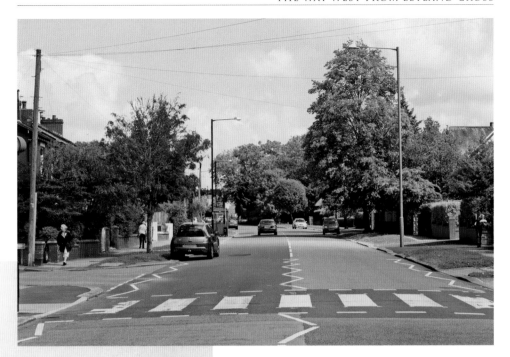

citation ran, '12 acres of potatoes, 2 acres of beans, 2 acres of turnips, 1 acre of vetches, 3 of old meadow, 1 acre of gardens, orchards etc. An excellent dairy cheese is made on the farm.'

POST-WAR SUBURBIA. By the 1950s the town's remarkable record in creating jobs led Lancashire County Council to see Leyland as an important area for re-housing in the North West, particularly from the Wigan area. Ultimately this would coalesce into plans for the Central Lancashire New Town. Fox Lane was to bear the brunt of housing development, and the sale of the ffarington estate in the late-1940s released large blocks of land. The former chairman of the local council, Dr William Fotheringham described this process in 1994: 'We built Broadfield estate because houses were needed for the people coming back from the war who didn't have the chance to get housing. It was officially opened in 1948, and Wade Hall was built shortly after.' Yet today Fox Lane still preserves a large slice of the town's history through the ffarington, Osbaldeston and Riley Almshouses, and the weavers' step-houses.

LEYLAND
CRICKET
GROUND

FOX LANE CRICKET field, 1904. The history of the
Leyland Cricket Club can be traced to a game between
Leyland and Chorley on the Vicar's Fields in 1848. The
prime movers were the Revd Gardnor Baldwin, the
vicar, and John Stanning, the local bleacher. Allen Hill
(1843-1910), a Yorkshire county cricketer, is the club's
best-known player. He took the first wicket in the first
ever test match in Australia, March 1877. This was also
the year from which the permanent record of games
played by the club begins. John Stanning's health began
to fail and his doctors advised a holiday in Egypt. He died
at Luxor on 5 March 1904. Both he and Allen Hill are
buried in St Andrew's graveyard. He left the Fox Lane
ground to the people of Leyland, and it is now known as
the Stanning Memorial Ground.

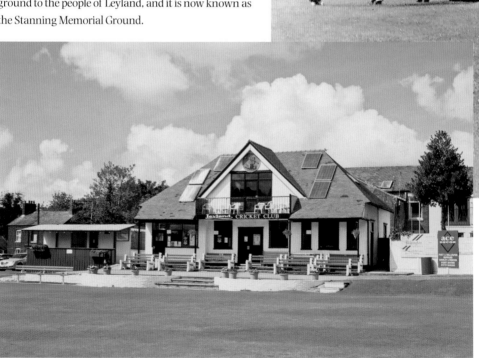

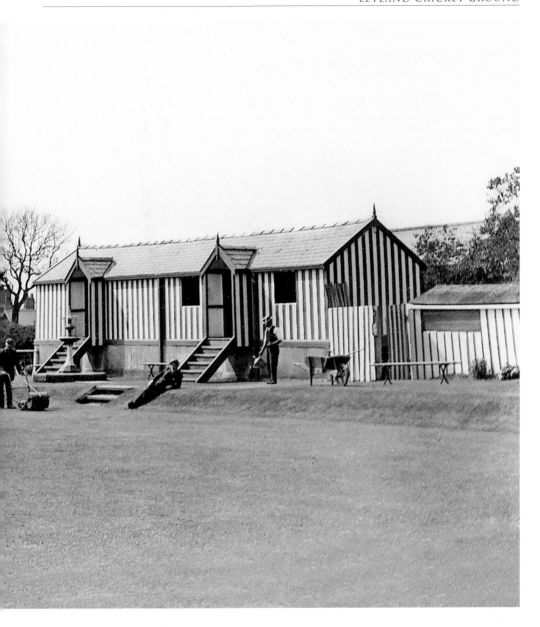

THE PAVILION, LEYLAND Cricket Club. Leyland CC merged with BTR CC in 2000 and with Leyland Motors CC in 2007, when both teams lost their grounds after the closure of their works. The team plays in the Northern Premier League. The cricket club is now a part of the Fox Lane Sports & Social Club, 'a major venue for multiple outdoor sports in Leyland'. The club's facilities extend over 7 acres in this lovely unspoilt corner of Leyland and include tennis courts and bowling greens. 2010 was one of the club's most successful seasons. Led by team captain David Makinson and professional Brett Pesler, the team won the championship of the Northern League. David described this as the best achievement of his career.

SEVEN STARS
FROM THE AIR

LOOKING SOUTH FROM the former Mount Pleasant Mill, Seven Stars, c.1925. In the mid-1920s this type of industrial photograph was very popular. The ancient line of Leyland Lane skirted the eastern fringe of the moss, and here was joined by two direct ways onto the moss, Slater Lane and Dunkirk Lane. Interestingly, the ring of roads around the site is much older than the mill itself,

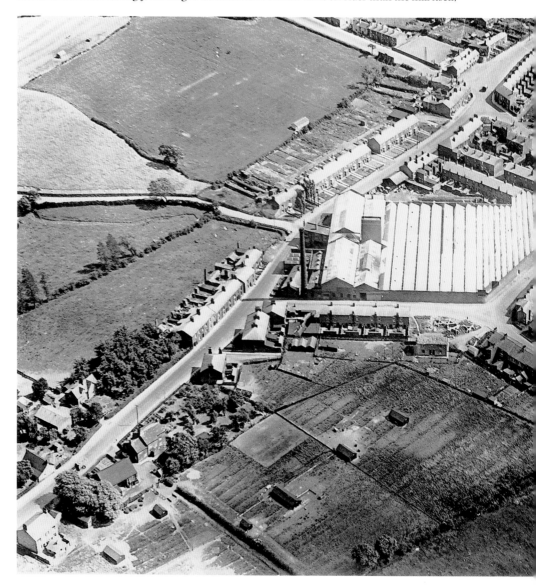

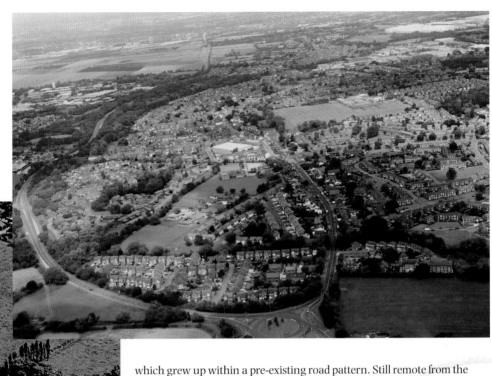

which grew up within a pre-existing road pattern. Still remote from the village, Seven Stars coalesced around its factory. Located on the manorial millstream, it originated as a sawmill, operated by Mr Mackerall, which Edmund Berry took over in 1871 for development as a weaving mill. By the outbreak of the last war, Andrew Berry & Sons (1920) was Leyland's largest weaving concern, running over 1,100 looms. Like Pilkington's sister mill at Earnshaw Bridge, it was diversifying away from cotton into man-made fibres and ran well into the 1960s.

LOOKING NORTH TO Seven Stars from the junction of Leyland Lane and the Schleswig Way, June 2011. The place of new roads to the Central Lancashire new town scheme is clearly apparent in this photograph. The Western Primary and Leyland Lane form a loop around Seven Stars, within which St Anne's RC and Seven Stars County Primary Schools and the former Mount Pleasant Mill (with its white roof) are conspicuous. Worden high school can also be seen, and the large building in the top right is the Global Renewables' plant at Farington. Trees along Longmeanygate trace the western rim of the town, and the Moss Side business park is conspicuous. Here also is the site of ancient Ambrye Meadows, and Leyland's lost hamlet of Honkington. On the eastern side, by contrast, the low-density housing that typified much of Leyland's post-war council development can be seen at Wade Hall.
(*Courtesy of South Ribble Borough Council*)

ST JAMES' CHURCH

ST JAMES' CHURCH and cottage, c.1905. The growth of the bleachworks and Mount Pleasant brought development to the whole length of Leyland Lane. The church was consecrated on St James' Day, 28 July 1855. It was founded by Sarah Esther ffarington as a memorial to her husband James Nowell, who died, aged thirty-five, in 1848; they had been married just eight months. The octagonal spire rises 148ft above the flat countryside of the moss, making it a landmark for miles around. The south aisle was added in 1870 by Susan Maria ffarington and contains a beautiful effigy of the foundress carved from Carrara marble. The thatched cottage appears on the ffarington estate survey of 1725 but by 1900 was one of a dwindling number of thatched cottages. Whilst many were re-roofed in one form or another, this one was demolished, and another bit of moss-land life in Leyland disappeared.

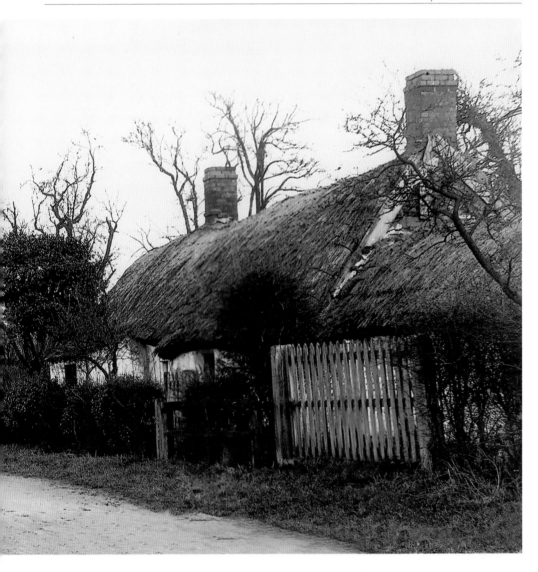

THE MODERN PHOTOGRAPH shows St James' church and school. The district about Leyland
Lane was transformed by the growth of the textile trade in the second half of the nineteenth
century, but this was as nothing to the future envisaged for it in the Central Lancashire New
Town. The population of Leyland was to treble in thirty years to reach 73,000 by 2001 (actual
figure 35,500). Much of this development was to be around the hamlet of Runshaw (population
280, target population 20,000) and Moss Side. In 1991 the *Leyland Guardian* reported that
building work in the Slater Lane-Dunkirk Lane-Longmeanygate was about to begin: 'When
finished it will be almost a duplication of the existing town.' Public services were expanded
accordingly, and this district has particularly good primary schools. St James', established by
Samuel Crook in 1770, was rebuilt on this site, and in addition to Seven Stars and St Anne's RC
Primary, Leyland's newest school, Moss Side County, was opened in April 1982.

SEVEN STARS AND LEYLAND LANE

THE ORIGINAL SEVEN Stars, *c*.1920. 'Seven Stars', usually a circle of six surrounding a central one, refers to the daughters of Atlas, who transformed themselves into stars in Greek mythology. The 'original' was built by John Atherton in 1686, and known as Atherton's. It is a nice example of a good quality porticoed house of the period and had stables to the rear. Though it was rented to 'Peter Weathersby of Leyland, Maltster' in 1708, presumably as an alehouse, it is only recorded as such in 1877. The present-day Seven Stars Hotel may have been built in the interim to account for the 'Original' element in the name.

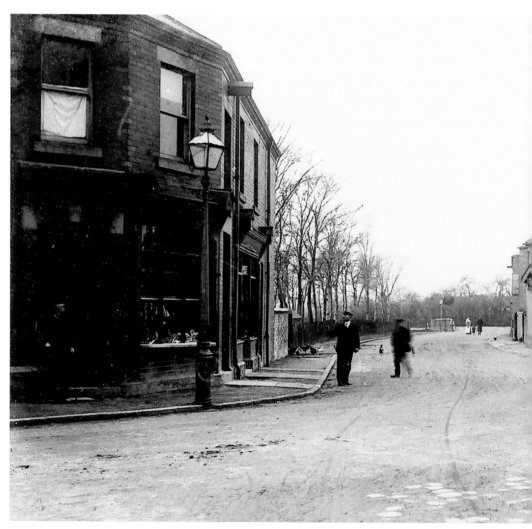

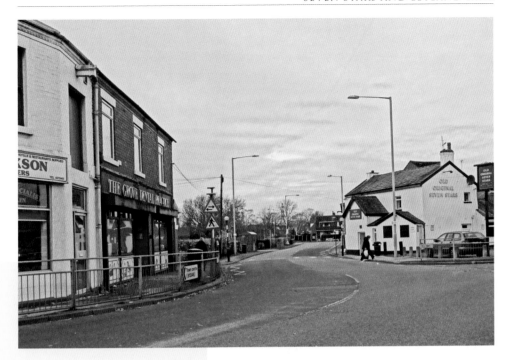

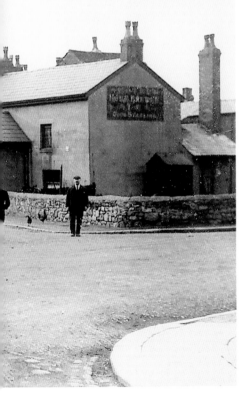

Long before the cotton mill developed, a distinct community had grown up here around the junction of Slater Lane, Fox Lane and Leyland Lane. It boasted another alehouse, the Farrington Arms, and the original site of the ffarington Almshouses, established here in 1607.

WITH THE OPENING of the Western Primary Road, Leyland Lane (a section of the old Penwortham and Wrightington Turnpike Trust) was bypassed by a direct route into Preston. Despite recent development, a number of interesting old houses can still be seen in the area. At Dunkirk Hall William Sumner had to pay for six hearths in 1664, and only Worden Hall and Charnock Hall had more. Langs Hall can boast an elegant three-storey Venetian-style wing and links with Captain Cook, whilst Peacock Hall had a concealed room and an eyewitness to the gunpowder plot. Public houses were a strong suit, and since many locals had the right to cut peat on the moss they no doubt did well from this passing trade. The 'Crofters' takes its name from a trade at the bleachworks: the landlord was noted for having the nightshift's pints waiting for them at 6 a.m.. Alternatively, the 'Dunkirk Hall' became for a time Leyland's newest pub in 1983.

DUNKIRK LANE
AND MOSS SIDE

DUNKIRK LANE, C.1920. The origin of the name is obscure but may be related to the important property Lostock, which changed its name to Dunkirk Hall before 1725. The lane was one of the ancient tracks used by summer grazers and peat cutters seeking access to Leyland Moss. In 1545 the local peat mosses were estimated to extend over 1,000 acres. Between here and Earnshaw Bridge, steady encroachments were made by a series of tracks or meanygates, eventually linking up to form the 'Long Meaniegate' in 1726. A meanygate is essentially a road onto the moss. These fine houses were built in the first years of the

century, in a tranquil quarter little changed from when Preston journalist Anthony Hewitson had dryly described it in 1872: 'This district is known as Leyland Moss – a flat, pastoral, peaty, moderately civilised part of the county.'

CENTRAL MOSS SIDE, 2011. With the New Town development, Moss Side, separated from Seven Stars by the River Lostock and the Western Primary road, has become a suburb in its own right. The original plan envisaged 'an early addition of 4,500 people' to the existing population of just 1,100, with employment available within Leyland itself and in the new Moss Side employment area. To this end a new residential district was built between Slater Lane and Dunkirk Lane. The full implications of the plan became apparent at the 1974 Public Enquiry and opposition was intense. Three years later the town's target population was scaled back by 80 per cent, and in 1981 it was announced that the Central Lancashire Development Corporation would close in 1985. In Moss Side, however, many of the local targets were achieved: today it has a population of 3,673 and is the largest supplier of pizzas to the Italian market.

THE ROUNDHOUSE
ON LEYLAND MOSS

THE ROUNDHOUSE ON Leyland Moss, *c*.1900. West
of Worden Old Hall the land surface falls steadily to
the line of the River Lostock, and a short distance
beyond to Leyland Moss. Though a primeval wasteland,
the moss provided a valuable source of peat and the
townships of the ancient parish had rights to it. One of
the earliest crossings was by the Sod Hall Meanygate;
this linked Longmeanygate to the 1761 enclosure roads
on the north side. The 'Farington' Roundhouse was an
octagonal, thatched, timber-and-daub structure, and
stood on the boundary of Leyland and Longton Mosses.
It was a popular walk and passers-by could obtain
refreshments, but though the track was gated at this point
it has not yet been possible to find legal evidence for the
collection of tolls. The few surviving photographs give a
vivid insight into a vanished mossland way of life that had
changed little in centuries.

DURING THE NINETEENTH century cultivation closed in on the Roundhouse from the north (Longton) and south (Leyland), whilst to the east Farington Moss was stripped of its peat and brought into cultivation after 1819. By the Second World War these provided some of the most fertile soils in the country. With the mild climate and the growth of large urban markets, a thriving market garden industry grew up, and this has extended greatly in recent years. Despite being without running water and electricity, the Roundhouse was a useful base for these activities long into the 1970s. However, a thunderstorm in June 1983 damaged the back of the house. Autumn gales, sightseers and vandals completed the destruction, and seventy-three-year-old Mr Wilf Halliwell had to move out. A variety of problems prevented the restoration of what had been an idyllic little house with its own secluded small garden, set in the hundreds of still empty acres to the west of Leyland.

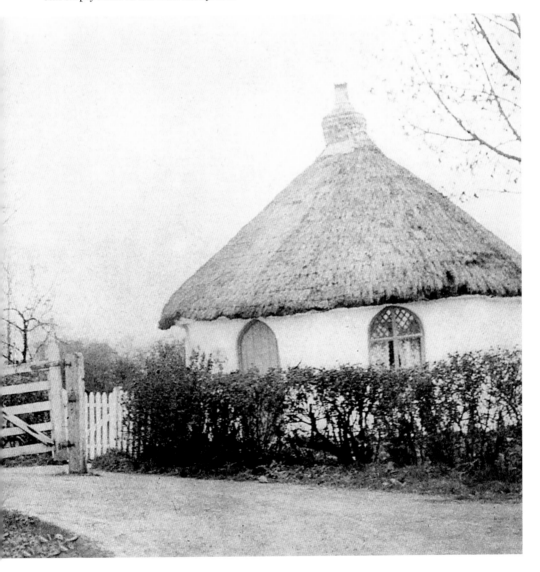

TOWNGATE

LEYLAND CROSS AND town centre looking north along Towngate, 1950. From Norman times Towngate had been the way between the great open fields, the Upper and Lower Townfields. In time Leyland's principal road junction would be in need of light and control. The first great improvement here came as early as December 1849. Having set up a gas-making plant behind the Ship Inn, the Oddfellows Society of Leyland installed gas lamps at the top of the Cross. Victoria's Jubilee in 1887 happily saw the removal of the gas lamps, restoration of the top of the shaft and the construction of a fine new drinking fountain. In 1934 the Minister of Transport, Mr Hore-Belisha, introduced a new type of pedestrian crossing indicated by flashing lights. It soon got the name of a Belisha beacon, and the first one in Leyland can be seen here. In 1950 the water fountain still wore its royal crown – does any reader know where it went?

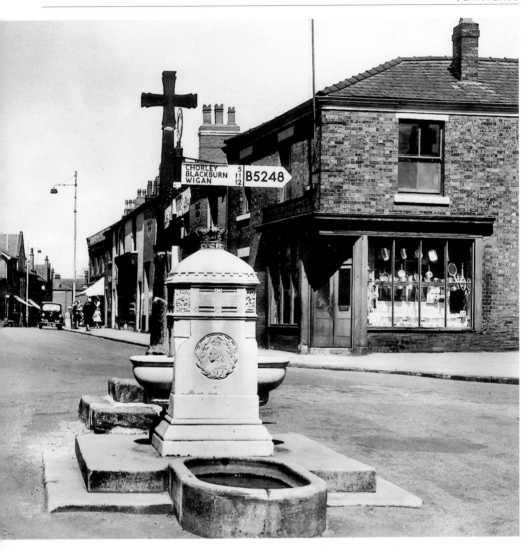

THE MODERN PHOTOGRAPH shows a single, large, town-centre supermarket. The great manufacturing plants overwhelmed the enlarged village coalescing along the line of Towngate and Hough Lane. The population passed 10,000 in 1931, 15,000 in 1951 and 20,000 in 1961. Leyland needed a town centre to reflect its growing importance. The potential for development along Hough Lane was restricted, so planners concentrated on the ancient centre around Leyland Cross. In the early 1950s the Civic Trust produced plans to modernise and improve the area in a sympathetic manner, but by the early 1960s a more forceful policy had emerged, requiring extensive demolition and the redevelopment of the entire area.

A simple comparison of the two views – though stark – conveys little of the trauma of these years. Half a century of town planning (the rise and fall of the Metrolands Development) divides them. By 1995 the area beyond the Cross was little more than a wasteland: these vast efforts by the public and private sectors had, it seemed, produced nothing.

A FUTURE DELAYED

TOWNGATE 1960: THE view of much of the old village centre seen from the top of Fox Lane, just before the developers moved in. A Fishwick's Leyland double-decker, service 111, waits at the bus stop at the top of Cow Lane to embark on the 7 mile run to Preston. The first shop on the left was Threlfall's newsagents. the next a confectionery shop. Harrison's Carriers were also located here. In the distance, across Cow Lane, was a fine three-storied house of around 1715. On the right, just in view, is the Roe Buck Hotel – Mrs Critchley's 'Stag' of around 1800-20. The next building (on the corner of Church Road) was John Heaton's ironmongers and sheet metal workers. He first appears in the 1881 census as a twenty-eight-year-old tin-plate worker, but by 1891 he had bought the

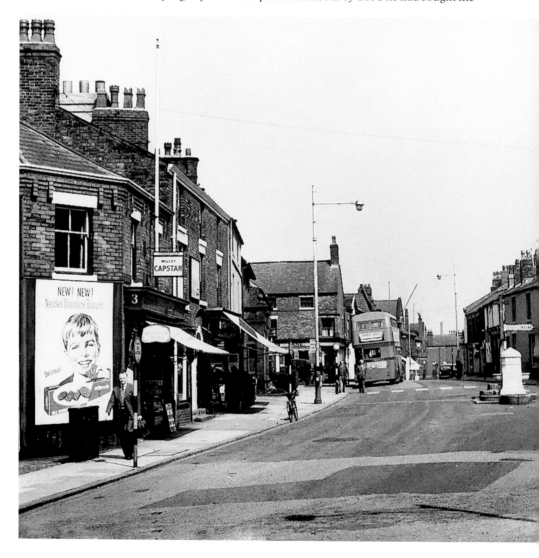

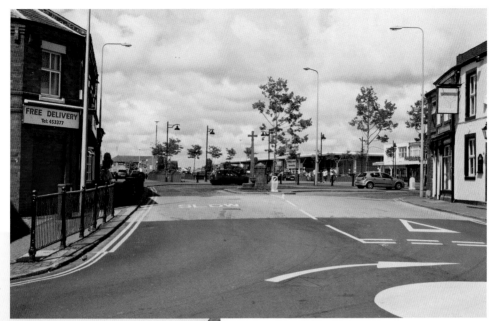

grocer's shop next door, the whole becoming the enlarged property that remained in business on the same site until well after the Second World War.

OLD MEETS NEW on Western Towngate. Plans for a new town centre were blown off course almost immediately by the Central Lancashire New Town scheme. Leyland's population was predicted to double to 50,000 by 1986 and reach 73,000 in 2001, which proved wildly optimistic: the town could never be more than a minor retail player. Thereafter the economic difficulties of the 1970s and planning delays led to short bursts of activity interspersed with long spells of inertia.

The council (1977) favoured a store, covered shopping mall and a variety of small retail shops; the developer, Metrolands, favoured a single very large 'big name' store. By 1978 an open market, row of small shops and a Co-operative store had been established and work was underway on the large Mainstop store. Yet ten years later the New Town plan had been curtailed and local industry was in rapid decline. The modern Co-op store closed in July 1990.

'ONE LARGE SHOP'

CORONATION ARCH, LOOKING north along Towngate, 1911. The steady clearance of the Leyland Cross area after 1960 swept away a community centuries in the making. Here Leylanders of all ages gather to celebrate the coronation of King George V in 1911. The town's extensive church-based community groups, thriving in the town's general prosperity and confidence in the years before the First World War, could mobilise considerable resources. They were the basis of the remarkable success of the May Festival, and the various patriotic outpourings such as this.

In 1905 the curate, Rev E.G. Marshall, had boasted, 'The Village is well off for manufactures, and work is therefore plentiful, a sure sign of the prosperity of the place... Leyland has the proud distinction of having invented the first steam lawnmower: Mr James Sumner being the

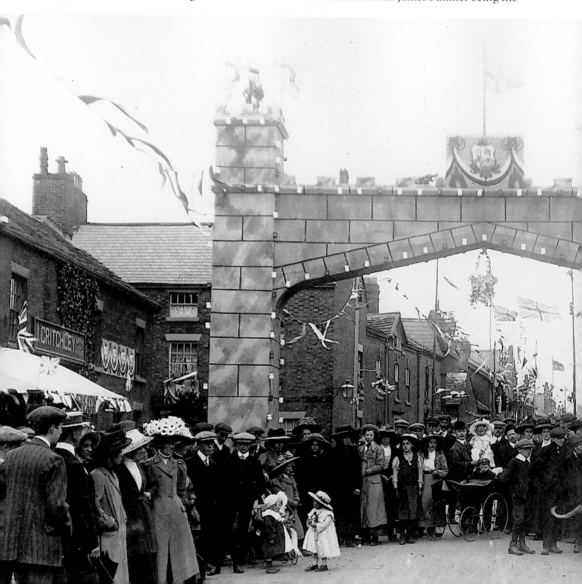

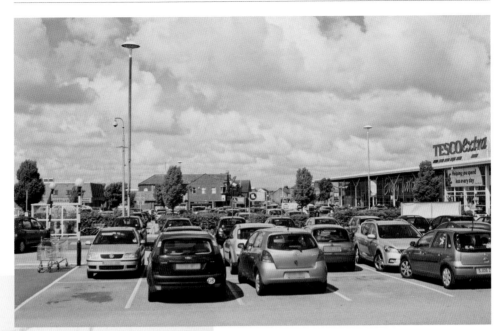

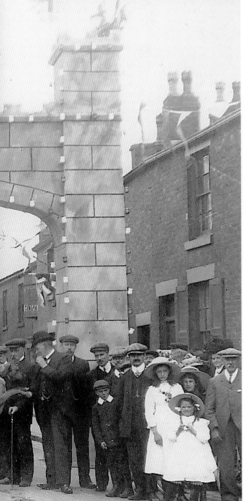

inventor... a managing director and also a partner
in the Lancashire Steam Motor Company Ltd, whose
extensive works are at Leyland.'

IN 1998 THERE was a quick change of direction.
The failure of the Western Towngate development
led to renewed emphasis on Hough Lane where a
revival was underway by 1995. Metrolands went into
receivership in July 1998 and much of the site was
derelict when news of Tesco's interest in a revived
'one large shop' scheme broke on 3 September.
Ironically, most of the Metrolands development was
to make way for it.

In December 1999 planning permission was
obtained, and work was scheduled to start in
September 2000. A year was spent preparing the site
for construction to begin in February 2002. Progress
was spectacular: by the end of March the steelwork
and roof were largely complete. A month later the
roof was on, and during May the petrol tanks were
installed, the glass windows fitted and the floor laid.
June saw the shelving, tills and lights arrive, July the
grass verges and trees planted and paving completed.
Tesco Leyland opened on 29 July 2002.

PUBLIC HALL

PUBLIC HALL, TOWNGATE, 1950. The barber, Booth Moss, in his white coat, has a word with shopkeeper Ben Pickup in his Triumph Mayflower, as a Fishwick's bus pulls out to pass. Built in 1899 by a group of local businessmen, the Public Hall was the hub of public and social life in Leyland. All council affairs were run from this building. At night many organisations used the upstairs rooms, whilst the large hall with its 'sprung' floor was the centre of social activity. The downstairs rooms were occupied by the council's offices, but on the extreme left of the photograph the 'angled corner' was the entrance to the District Bank, which in the 1920s boasted an electric clock over the door. Squire ffarington used to walk up from Worden Hall just before 11 a.m. to

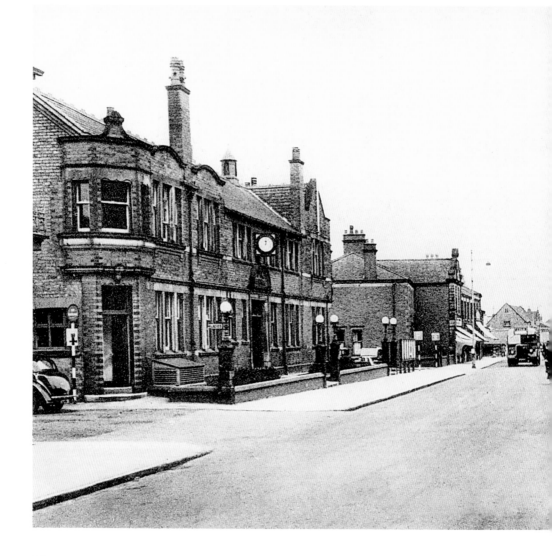

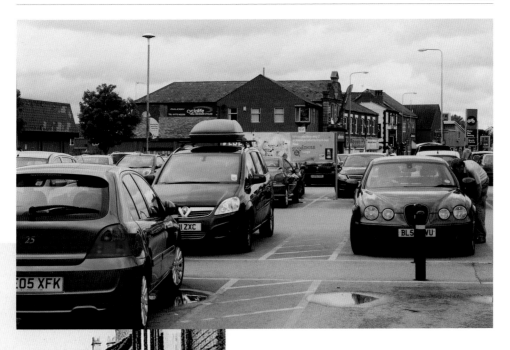

check his pocket watch. In 1989, after recently being re-roofed and redecorated, the Public Hall was demolished, sweeping away forever any lingering village atmosphere.

TODAY LEYLAND CROSS is dominated by a vast supermarket and car park. It would be wrong to entirely dismiss the work of the post-war planners. A civic landscape was created, providing a new library (1974), leisure centre (1974-81), civic centre (1975), magistrates' court and police station (1993).

With the apparent completion of the project, attention has shifted to the development of the Hough Lane shopping area around the new market hall and the creation of a large cluster of national retailers off Golden Hall Lane. In short, the whole pattern of retailing has changed.

The store's sales area covers 61,000sq ft, and employs 354 staff, half of which are part time, to serve 42,000 customers with goods worth £1 million each week. Forty-two 40ft articulated lorries supply 23,000 lines of stock, 74,000 gallons of fuel and 13,200 bananas. On the shop floor, the manager walks 12 miles per day.

A QUIET CORNER TRANSFORMED

COTTAGES AND HOUSES along the west side of Towngate, *c*.1910. This picture illustrates the piecemeal nature of the development of much of old Towngate. The George IV hotel is just out of the shot on the extreme left. A very interesting seventeenth-century house had been demolished to make way for the first three houses. Between them and the building end-on to Towngate was a lane leading to Orange Square. This in turn is followed by a row of low old houses known as Duck Row. Their floor level was below the street and on entering one had to step down. This made them liable to flooding during periods of heavy rain, and the inhabitants were said to have webbed feet! Beyond this row, the high roof of St Mary's Catholic school can be seen. Built in 1897, this, in turn, had replaced the Ebenezer Independent chapel, built by the early Leyland Congregationalists in 1844.

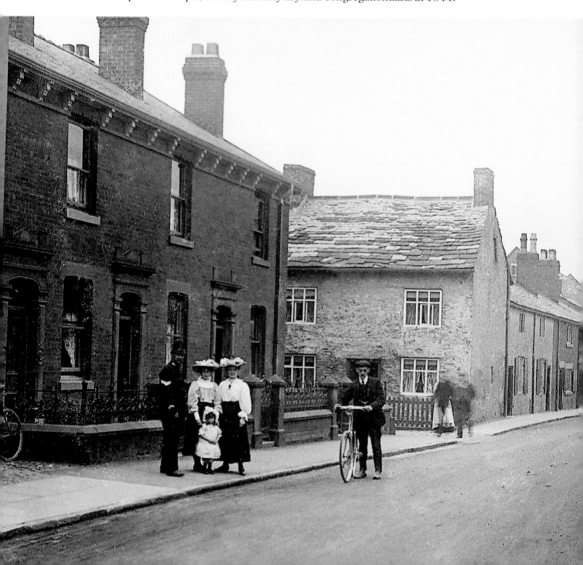

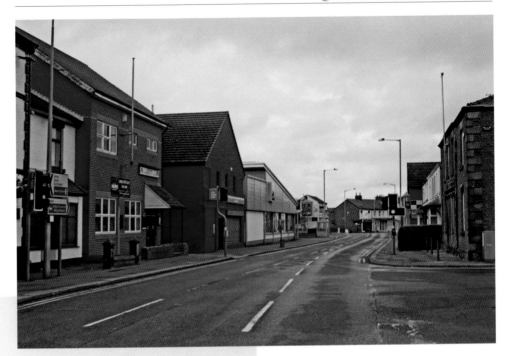

TOWNGATE, LOOKING NORTH from the corner of St Andrew's Way. This sedate tract of Towngate was transformed into a busy road junction by the opening of St Andrew's Way, the relief road for Leyland Cross. Though the old weavers' tavern, the George IV, survives as Barristers, the left-hand side has been rebuilt. An Aldi supermarket occupies Duck Row; the old Catholic school (subsequently Leyland Garage) is now the supermarket car park. The Ship Inn and Garden Terrace can be seen in the distance. In the 1930s this was known as Mrs Jolly's Corner (in homage to her sweetshop) and marked the north end of the old linear village. But with the shopping developments to the north and south it now finds itself at the very heart of Leyland.

The right-hand side is dominated by the 1857 police building, which from the 1930s housed the town's library. Among the range of small shops here is Leyland's last bookshop, Great Grandfather's.

SOUTH FROM THE CROSS

THE VIEW SOUTH from Leyland Cross, *c.*1910. The road south here was known as New Lane, following its diversion to form Worden Lane in the 1840s. This moved the ancient route out of what had become Worden Park, the principal home of the ffarington family, lords of the manor since the early thirteenth century. With the parish church to the rear on the left, this is the most historic area of the town: for centuries this was 'Leyland'.

The Cross may or may not have been smashed by angry Puritans, but the town's stocks and whipping post stood here well into the nineteenth century. On the left stands the Roebuck, perhaps

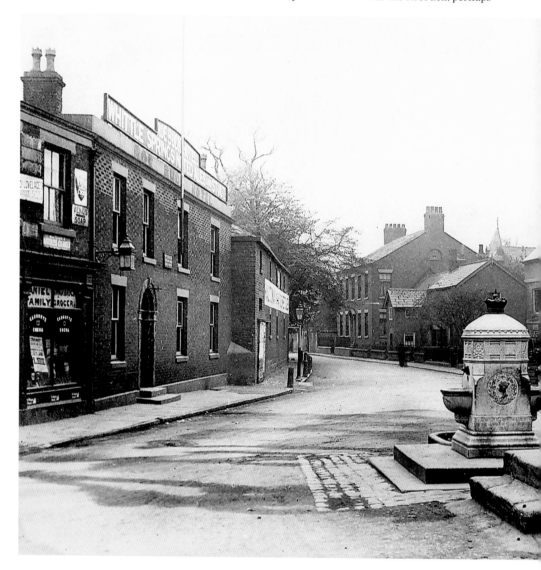

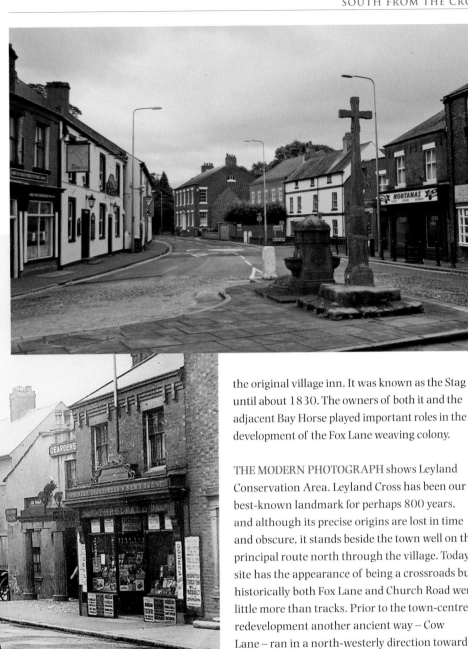

the original village inn. It was known as the Stag until about 1830. The owners of both it and the adjacent Bay Horse played important roles in the development of the Fox Lane weaving colony.

THE MODERN PHOTOGRAPH shows Leyland Conservation Area. Leyland Cross has been our best-known landmark for perhaps 800 years, and although its precise origins are lost in time and obscure, it stands beside the town well on the principal route north through the village. Today the site has the appearance of being a crossroads but historically both Fox Lane and Church Road were little more than tracks. Prior to the town-centre redevelopment another ancient way – Cow Lane – ran in a north-westerly direction towards present-day Broadfield Drive. The area to the north of the cross was pedestrianised in 2002.

It could have been much worse: in 1900 Leyland Baldwin was alarmed to hear of a scheme 'by a man of authority' to remove the Cross and replace it with an incandescent lamp 'flanked on either side by a public urinal'!

BACK LANE
BECOMES
LANGDALE
ROAD

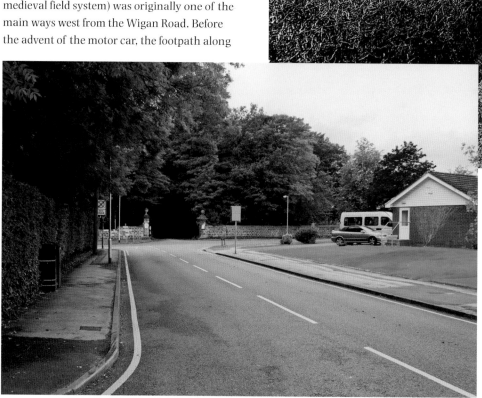

THE SECOND PARK entrance and lodge, seen from Back Lane, now Langdale Road, c.1910. The creation of Worden Park in the early 1840s led to the diversion eastwards of the ancient way south from Leyland Cross. It was probably during the construction of modern Worden Lane that the Worden Hoard of 120 late third-century Roman coins was found here in 1850. Until the enclosure of the park, Back Lane (around the 'back' of the medieval field system) was originally one of the main ways west from the Wigan Road. Before the advent of the motor car, the footpath along

country lanes was kept separate from the roadway itself by a grass verge; the survival of this practice may be apparent in the arrangement to the left of the road in this photograph.

THE ENTRANCE TO Worden Park from Langdale Road can be seen in the 2011 photograph. The Holt Brow Lodge was demolished in the late 1930s; Back Lane was cut by the M6 motorway and became Langdale Road. The enormous Worden housing estate was constructed over the Far Townfield in the late 1960s. Today Langdale Road is the site of Runshaw College, formed in 1974 by the amalgamation of the sixth forms of Parklands High School in Chorley and Leyland's Balshaw's Grammar School. Serving the sixteen to eighteen year olds of Chorley and Leyland, Runshaw received the best Ofsted report of any further education college in the country in 2005 and became a Beacon College the following year. The Liberal Democrat MP Tim Farron, for Westmorland and Lonsdale, is a former student.

WORDEN HALL

A PANORAMA OF Worden Hall from the south, *c.*1870. James Nowell ffarington inherited the family estate in 1837 and almost immediately had to undertake the rebuilding of the house under the direction of Anthony Salvin. Over £12,000 was spent to produce one of the county's showcases. On his death in 1846 his widow and two sisters lived on at the hall. Though the family had been resident since the twelfth century, this was one of a series of tragedies that befell the succession with the estate passing to ever more distant 'cousins' at each stage.

This photograph, taken in the early 1870s, shows the sisters Mary Hannah and Susan Maria with their personal servants, in the Italian garden. Mary Hannah was a gifted natural scientist and Susan Maria a leading historian, who also proved herself a good estate manager. Though it still comprised almost 1,400 acres in Leyland alone, she found the running of the house massively expensive.

LEYLAND'S PARK. IN 1941 an electrical fault in the attics caused a fire that extensively damaged the upper floor of the house. Nobody was injured and relays of local people rescued much of the contents.

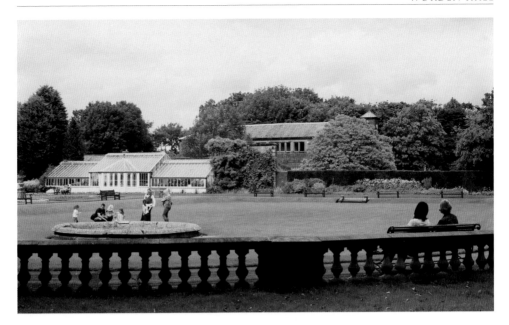

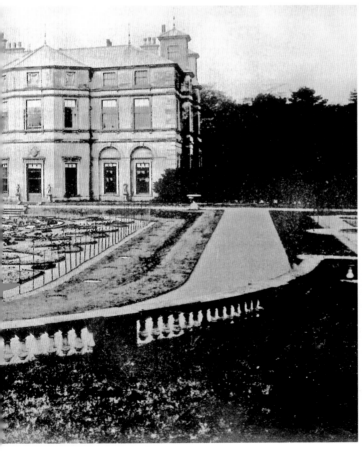

Henry Nowell ffarington moved to Pilling for the winter and planned to restore the house, but wartime controls prevented this. In the sale of large tracts of the estate that followed his death in 1947, Worden was acquired by the local council for around £23,000. Today the park attracts 200,000 visitors a year.

Reduced to two-storeys, the hall was viable for use by various local groups until it was finally demolished in 1968. But those buildings undamaged by the fire – notably the Derby Wing – survive and can be seen in this picture. Improvements were made under the Jobs Creation Scheme, and the Worden Arts Centre was established in 1984.

THE BIG HOUSE

THE FRONT OF Worden Hall viewed from the south-east corner. Taken around 1900, this is one of the best views of the house. The east-facing entrance hall, seen to the right, gave access to a suite of public rooms, with the family bedrooms on the first floor and the staff bedrooms above them. The house was built in the fashionable Italianate style, and the stuccoed walls were given a warm tint reminiscent of a Tuscan villa.

The only part of the pre-1840 house (Shaw Hall) to survive was the Grecian Gallery that formed much of the south side. It was located on the first floor, giving fine views of the ornate flower-filled parterre in the

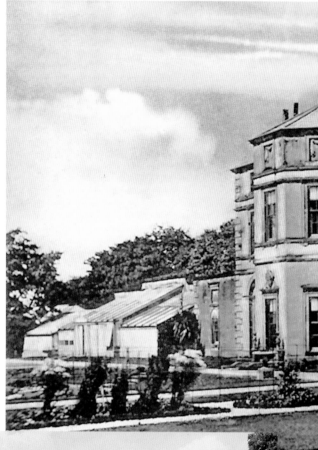

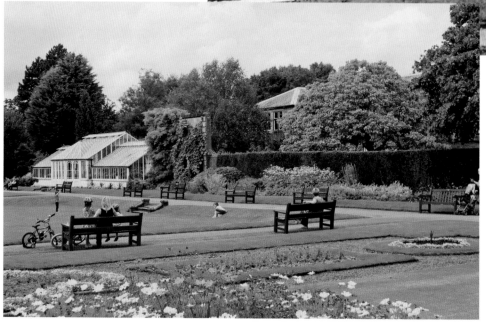

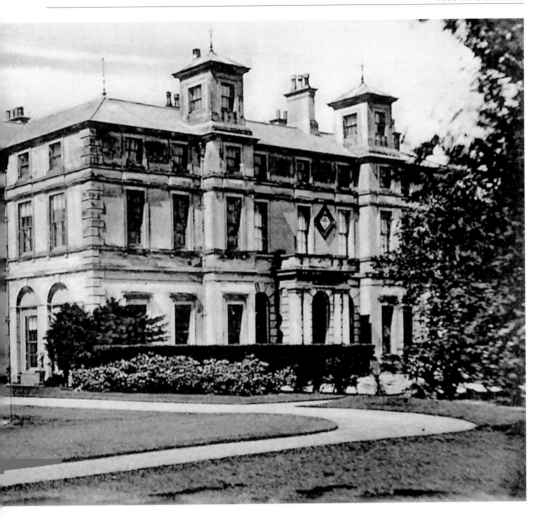

garden below. It had been built by Sir William ffarington to house the antiques he brought back from his Grand Tour of Italy in the 1750s.

WORDEN PARK, 2011. It was Worden's misfortune that the National Lottery Heritage Fund did not exist in the 1960s, but in recent years a number of bids for funding have been made and the future still beckons. On the positive side, the creation of the public park has restricted housing development along this section of the south side of the town, and the large ffarington collection of estate and family papers had been removed to the Lancashire Record Office (now in Bow Lane, Preston) months before the fire.

A number of initiatives are underway and the walled fruit and vegetable garden tucked away behind the house is undergoing progressive restoration by the Brothers of Charity and is a popular visitor attraction. With the death of the last squire at Worden in 1947, the estate and lordship of the manor of Leyland passed to Sir Henry Farrington of Somerset, whose son is today representative of a family extending back in Leyland for over fifty generations.

A VISION REALISED

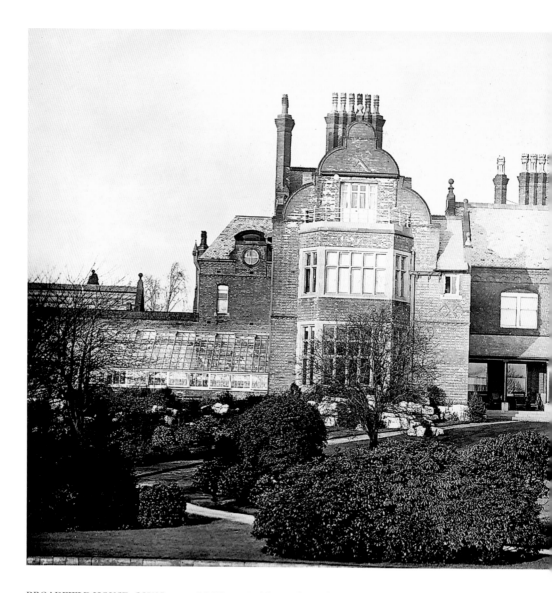

BROADFIELD HOUSE, COW Lane, *c.*1905: a suitable residence for one of the town's leading citizens, John Stanning. He encouraged Richard Sumner, revived Leyland Cricket Club and purchased the Old Grammar School for use as a parish hall – thus ensuring the future town museum's survival when the school closed in 1874. Stanning had come to Leyland from Halliwell with his father in 1871 to take over the old bleach works at Shruggs. An extremely shrewd and well-educated businessman, he was the first chairman of the Bleachers' Association, the great cartel of British cloth finishing firms. Stanning built the house alongside his Broadfield

works on land rented from the ffaringtons, who stipulated that he should spend at least £5,000 on constructing it. St Mary's Roman Catholic church and the popular Shruggs Wood nature reserve and lakes occupy the site today.

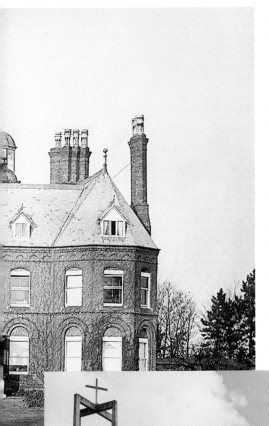

ST MARY'S CHURCH was the brainchild of Fr Edmund FitzSimons, who had toured Europe in search of the latest experimental design. The circular design, by Jerzy Faczynski of the Liverpool firm Weightman & Bullen, was strongly influenced by plans for Liverpool's Metropolitan cathedral, and the plan drawings date from 1961. Robert Proctor describes it as 'a thought-provoking treasure-trove of post-war religious architecture, art and design'. The 119ft diameter building is made of concrete, much of it cast in situ. The lower walls comprise Dalle-de-Verre windows ('coloured chunky glass set in concrete') by Patrick Reyntiens; the Stations of the Cross by Arthur Dooley are a national treasure. The church is set within an Italian piazza and has a free standing bell tower 88ft high, much admired by Nikolaus Pevsner. In short, this is one of the finest modern buildings in the North: the realisation of what Leyland Baldwin, a century before, hoped future generations might achieve.

Other titles published by The History Press

A Brief History of Lancashire
STEPHEN DUXBURY

We start with the beginning – the moment when the detritus of a dying star, spinning through the depths of the Milky Way, began to cool and coalesce, and rain – typically for Lancashire – began to fall as the moisture in the new atmosphere began to condense. A planet was formed, and history as we know it began. Racing through the history of Lancashire, this book will tell you everything you ought to know about the dramatic and fascinating history of the county – and a few things you never thought you would.

978 0 7524 6288 2

A Grim Almanac of Lancashire
JACK NADIN

A Grim Almanac of Lancashire is a day-by-day catalogue of 365 ghastly tales from around the county dating from the twelfth to the twentieth centuries. Full of dreadful deeds, macabre deaths, strange occurrences and heinous homicides, this almanac explores the darker side of the county's past. If you have ever wondered about what nasty goings-on occurred in the Lancashire of yesteryear, then look no further. But do you have the stomach for it?

978 0 7524 5684 3

Infamous Lancashire Women
ISSY SHANNON

From the notorious Pendle Witches, whose nefarious activities in the seventeenth century led to death and disaster, to the reviled Myra Hindley, the most hated woman in modern criminal history, Issy Shannon's new book is a riveting roll-call of Lancashire women truly deserving of the title 'infamous'. Alongside the Manchester baby-farmer and the unfortunate Lady Mabel Bradshaw of Wigan, who unwittingly committed bigamy, are witches, fraudsters, cross-dressers and thieves and women notorious as mistresses to the highest in the land.

978 0 7509 4969 9

More Lancashire Murders
ALAN HAYHURST

Alan Hayhurst brings together more murderous tales that shocked not only the county but made headline news throughout the nation. They include the case of Oldham nurse Elizabeth Berry, who poisoned her own daughter for the insurance money in 1887, and Margaret Walber, who beat her husband to death in Liverpool in 1893. Alan Hayhurst's well-illustrated and enthralling text will appeal to everyone interested in the shady side of Lancashire's history.

978 0 7524 5645 4

Visit our website and discover thousands of other History Press books.
www.thehistorypress.co.uk